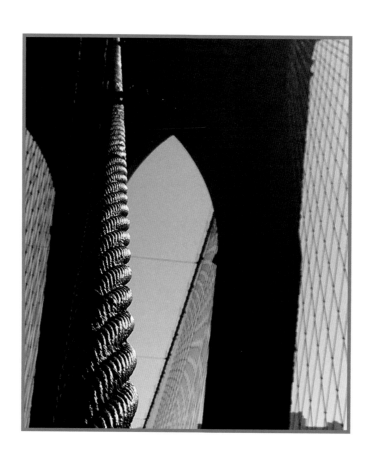

In the Shadow of Genius

THE BROOKLYN BRIDGE AND ITS CREATORS

Barbara G. Mensch

EMPIRE STATE EDITIONS

An imprint of Fordham University Press
New York 2018

To My Son, Jesse

Visit us online:
www.empirestateeditions.com
www.fordhampress.com

Library of Congress Control Number: 2018937119

Reproduction, printing and binding in Italy
by Tecnostampa, Pigini Group Printing Division, Loreto.
20 19 18 5 4 3 2 1
First edition

. . . [T]he time will come when you are thrown back on your own resources and unless you have the true stuff in you, failure is the inevitable result.

—Washington A. Roebling

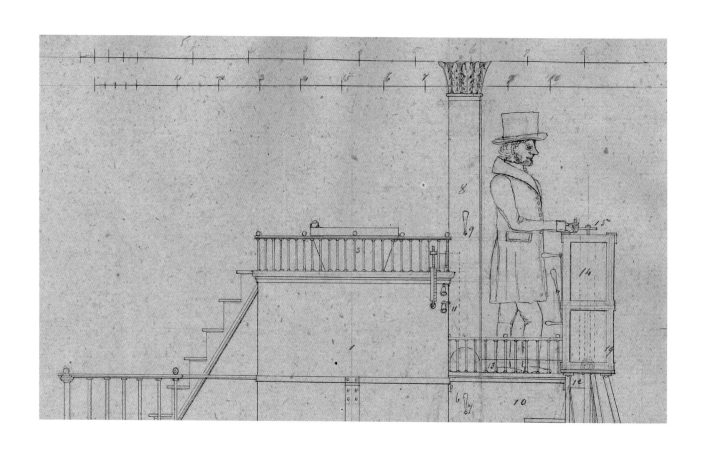

FOREWORD

When I first met Barbara Mensch in 2008, she introduced herself as a Manhattan-based photographer who was working on a series of photographs of the Brooklyn Bridge. Having just completed an exhibition on the Roeblings, the designers and builders of the bridge, I was well aware of the long shadows that their most famous creation seemed to cast on the American imagination. The Brooklyn Bridge has inspired writers (from Hart Crane to Marianne Moore to Jack Kerouac), painters (most notably Georgia O'Keeffe), and photographers (including Alfred Eisenstadt, Consuelo Kanaga, and Frank Spadarella). The Rutgers University Libraries Special Collections and University Archives, where I have had the good fortune to work since 1992, receives frequent requests from researchers—from as nearby as Trenton, New Jersey to as far away as New South Wales, Australia—to use the letters, drawings, writings, books, and photographs that make up Manuscript Collection 654, the Roebling Family Collection.

The Roebling Collection originally came to Rutgers in 1958 as a bequest from the estate of John A. Roebling II, the son of Washington A. Roebling, the builder of the Brooklyn Bridge. JARII, as he is known in archival shorthand, chose to divide the collection, donating the family papers to the local institution, Rutgers University; and the engineering drawings to Washington Roebling's alma mater the Rensselaer Polytechnic Institute. Since that time, the Rutgers' collection has grown, thanks to additional donations from the Roebling family and judicious purchases by my predecessors. As a young curator, I knew it was one of our most important collections, then under the stewardship of my more experienced colleagues. In 2003, I reluctantly took on the completion of a project funded by the US Department of the Interior's Save America's Treasures program to organize and microfilm the Roebling Family Collection.

The culmination of this project was an exhibition timed to coincide with the bicentennial of John A. Roebling's birth in 2006. Rutgers' *Philosopher, Engineer, Tycoon: John A. Roebling and His Legacy*, was one of many exhibitions, conferences, and publication projects that marked this important anniversary.

I soon became fascinated by the Roeblings myself. At the heart of that family's story lies the drama surrounding the design and building of what was originally known as the East River Bridge, a project begun by patriarch John A. Roebling and completed by his eldest son Washington and daughter-in-law Emily. Handling historical documents every day, I was still awed by the battered notebook in which John Roebling scribbled a rough but recognizable drawing of the bridge. I struggled to understand the period after John Roebling's death, when Washington Roebling, bedridden with caisson disease, attempted to retain control of the project, with his wife Emily serving as his amanuensis and liaison with city officials and construction crews at the bridge site.

I discovered that the secondary sources—a common shortcut for the busy curator—were not always reliable. The Roeblings' first biographer, Episcopalian priest and Trenton neighbor Hamilton Schuyler, made sure that the family retained firm control of the narrative in his respectful 1931 work, *The Roeblings*. Another early biographer, engineer David B. Steinman (who was born in lower Manhattan and, like Barbara Mensch, lived in the shadow of the Brooklyn Bridge), was in charge of a major rehabilitation of the bridge beginning in 1948. His much-quoted *Builders of the Bridge* (1945) helped perpetuate some of the Roebling mythology. For instance, he gives most of the credit for the design of the bridge to John Roebling, thus minimizing Washington's and Emily's roles. The historian is forced to be an archaeologist, excavating layers of misconceptions in the search for meaning. Even more misleading is the depiction of the building of the bridge in popular culture, where John and Washington Roebling are regularly conflated into one person. The sad fact that Washington Roebling's nephew and namesake Washington A. Roebling II was drowned on the *Titanic* just adds to the confusion.

The Roebling Family Collection itself, which comprises sixty-two archival boxes of various shapes and sizes and forty-five oversize map drawers, yields no easy answers. As a curator, I became used to seeing researchers defeated by the volume of books, articles, and archival material on the Roeblings. I had almost forgotten about

Barbara Mensch when she came to the Rutgers archives again in 2014. I soon realized, however, that Barbara was not the average researcher. Seeing her strikingly beautiful and original photographs of the Brooklyn Bridge, I realized that she was not the average photographer. For over thirty years, Barbara has lived on Water Street in lower Manhattan next to the Brooklyn Bridge. She has photographed it at all times of day, all seasons of the year, from both inside and out.

After years of living with the bridge, Barbara Mensch became fascinated by the people who designed and built this amazing structure. Barbara Mensch is a noted documentarian as well as an art photographer. Her books, *The Last Waterfront* (1985) and *South Street* (2007), are powerful records of the vanished lower Manhattan docklands. In *South Street*, Barbara interviewed workers at the Fulton Fish Market, telling their stories in words and images. Her photographs hum with empathy: she brings a rich understanding of lived experience to a story from 150 years ago, the saga of the Roebling family and the Brooklyn Bridge. Barbara was led to the Rutgers archives by her passion for getting at the truth of a story. For hours, she sat patiently at the microfilm viewer, trying to understand John Roebling's Hegelian rants and quietly perusing illegible correspondence and cryptic engineering drawings. Her photographic journey then took her further afield: to Mühlhausen, Germany, the birthplace of John Roebling; to Saxonburg, Pennsylvania, the tiny hamlet that he founded in 1832 upon his arrival in the United States; and to Cincinnati to see the only other Roebling bridge that still stands in its original form. The Cincinnati-Covington Bridge over the Ohio River, today known as the John A. Roebling Suspension Bridge, was the longest of its kind when it opened in 1866. Overshadowed by the highway crossing next to it, it is clearly a prototype for the Brooklyn Bridge.

I am honored to present Barbara Mensch's *In the Shadow of Genius*. I hope that some of you, like Barbara, will be inspired to visit Rutgers University and see for yourselves the records that John, Washington, and Emily Roebling and their descendants left behind—a legacy that Barbara Mensch vividly brings to life in this volume.

Fernanda H. Perrone
New Brunswick, New Jersey
2017

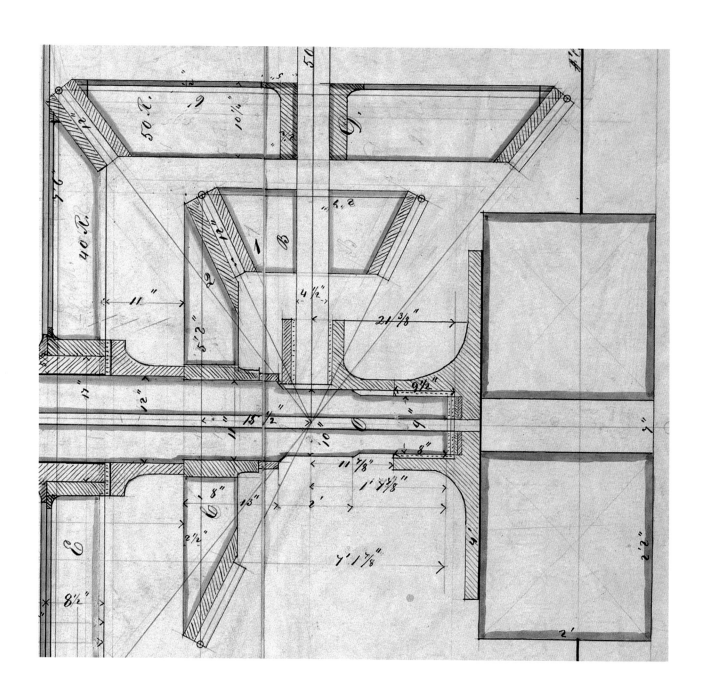

In the

Shadow

of Genius

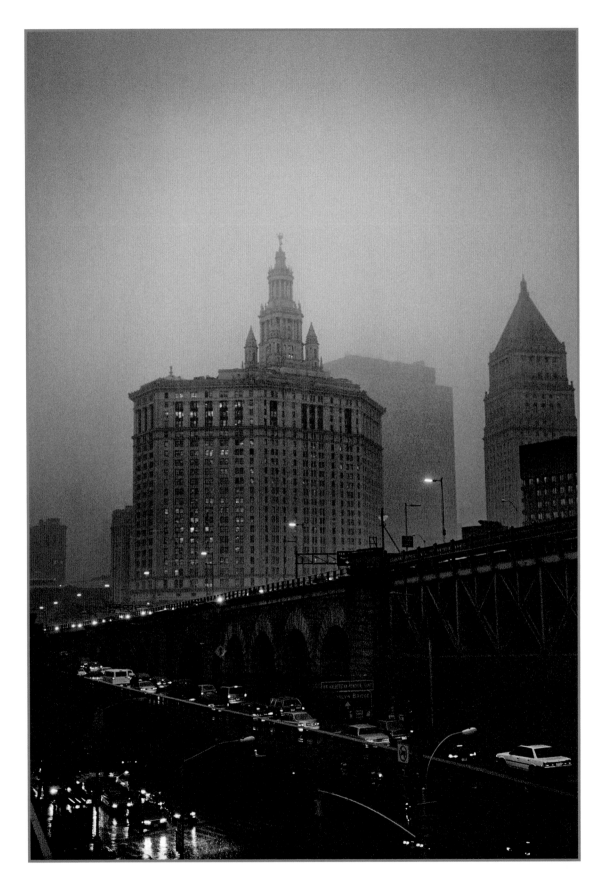

Figure 1.The municipal building, 1990.

When I was in my twenties, I moved to a maritime warehouse, located in the shadow of the Brooklyn Bridge, one of the world's most treasured icons.

The bridge loomed outside my window as a constant and relentless presence, resonating with an inexplicable spiritual power.

As I was drawn to photograph it during its most dramatic and visually compelling moments, my meditations upon it evolved into a profound curiosity. I wanted to know more about its principal creators: John, Washington, and Emily Roebling.

I would soon be immersed in the exploration of the enthralling tale of three distinct lives. Their stories would be revealed through a trail of documents: notebooks, letters, memoirs, diaries, magazine publications, newspaper clippings, drawings, and photographs housed in several university archives.

I traveled to the sites where they lived and worked to create images that would capture the essence of their life experiences. This journey took me to locations in New York, Pennsylvania, Ohio, Kentucky, and Germany.

Beyond the resolve which John, Washington, and Emily Roebling shared in common, it was their distinct and different capabilities which brought the Brooklyn Bridge, a masterwork of genius, to fruition.

If the Brooklyn Bridge is a work of genius, how do we define this genius? Each of its creators brought to the masterpiece unique experiences and expertise. How does one find or even begin to define this genius when the work required the powers of all three?

This book presents the findings of my quest.

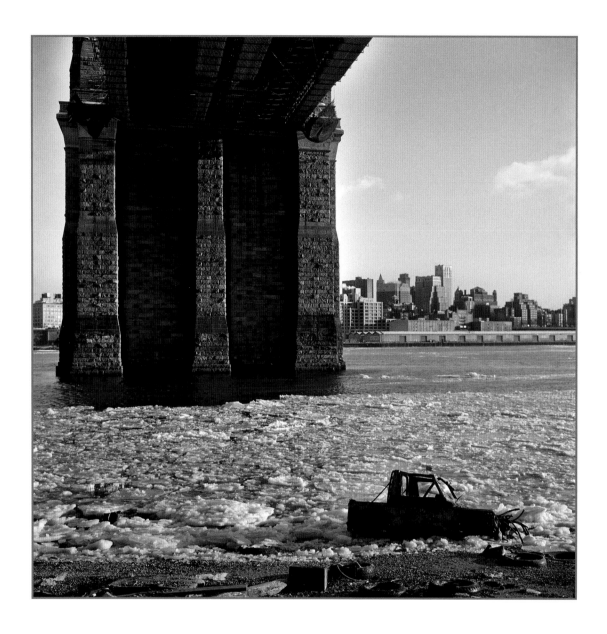

Figure 2. Junked car under the bridge, 1980.

The Brooklyn Bridge was a constant reminder of life in the metropolis. Day and night, there was an endless movement of cars, of people on foot, and of bicycle riders traversing the span. When I walked across the bridge, the vibrations reverberated and made the structure seem alive with an energy all its own.

The bridge created its own music. The continuous drone of traffic passing overhead sounded like a swarm of oncoming bees. This *force* woke me in the morning and lulled me to sleep at night. My windows faced west toward the large stone structure known as the approach, where traffic ascended onto the span. Rising above the structure, the Municipal Building, with its decorative dome and beautiful

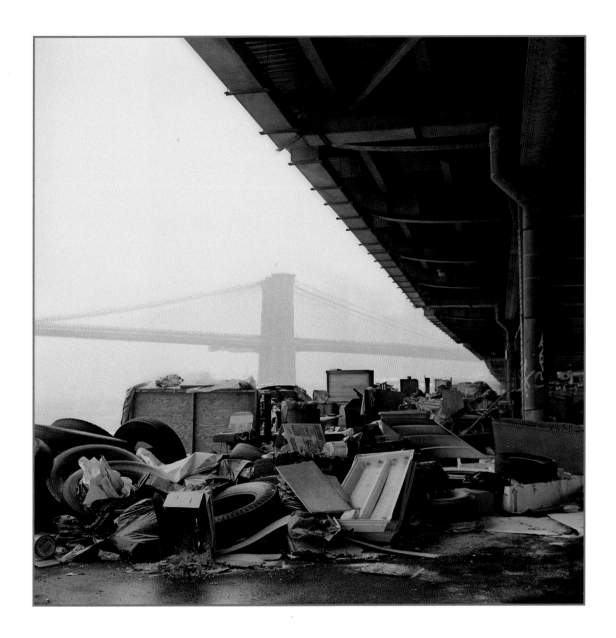

golden statue on top, reminded me of a grand European palace.

The dynamic presence of the bridge quickly dissolved the minute I left my front door. The neighborhood around the Brooklyn Bridge was a no man's land where many of the inhabitants—the homeless, workers at the city's fish market, and artists like me—were free from scrutiny. Seagulls, stray cats, river rats (and an occasional human body that washed ashore after the spring thaw), all could be found near the water's edge. I also experienced many fires, some of which could be viewed from my windows and rooftop, and in some instances from the bridge itself.

Figure 3. Under the viaduct, looking south toward the Brooklyn Bridge, 1980.

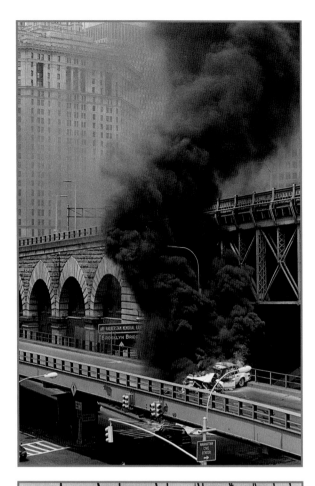

Figure 4. Fire on the ramp of the approach, 1987.

Figure 5. Fire at the Fulton Market as seen from the Brooklyn Bridge, 1996.

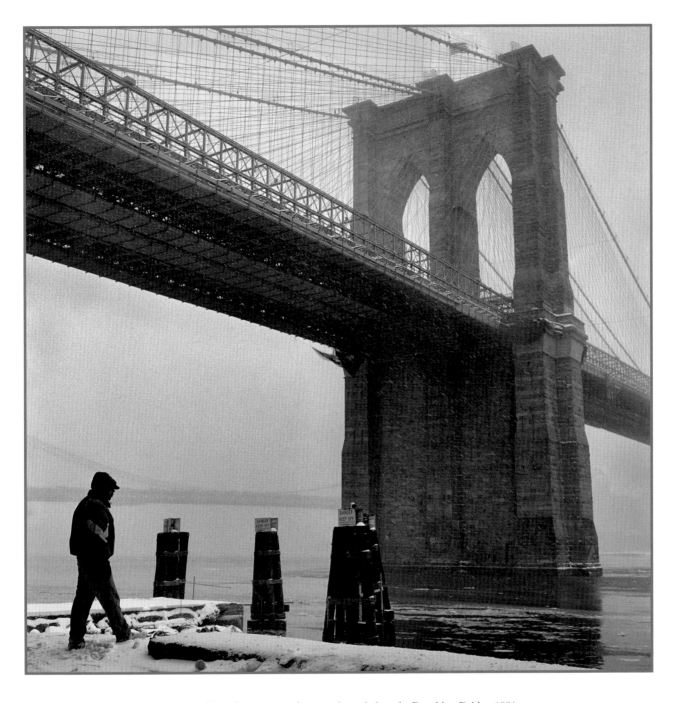

Figure 6. Homeless man on the waterfront, below the Brooklyn Bridge, 1981.

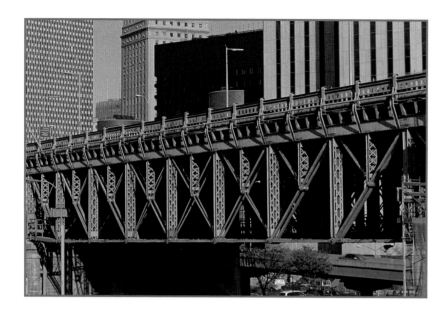

Figure 7. Roadway over Pearl Street connecting the approach to the span of the Brooklyn Bridge, 1999 (detail).

Each day was a unique romantic interlude. The changing light transformed the bridge and the river that ran through it. Captivated by its beauty, I began to think of the Brooklyn Bridge as my muse and photographed the structure in all seasons. It was inevitable that in my mind's eye, I was reminded of Cezanne's paintings of Mont Sainte-Victoire, Hiroshige's woodcuts of Mount Fuji, and Monet's studies of the Rouen Cathedral.

In its turbulence, the East River had a life of its own. On rare occasions, the sudden change in cold and warm temperatures would drape the towers with a fog so thick that the city disappeared. The fog was beautifully described in 1873 by the bridge's master mechanic, E. F. Farrington, while standing on top of the New York tower:

> It was in the early morning, when a dense fog covered the whole region, that having the occasion to examine some machinery, I went on the tower before the time for commencing work. I shall never forget that morning. I found the fog risen to within twenty feet to the top of the tower, and there hung . . . dense, opaque, tangible . . . the spires of Trinity in New York, and in Brooklyn, and the tops of a mast of a ship in one of the dry docks, with the roof of the bridge towers were all that were visible of the world below.[1]

I often walked home down Pearl Street, a wide street that passed beneath "the approach," a century-old roadway linking the anchorage to the span of the bridge. Pearl Street separated the ancient stone structure in two.

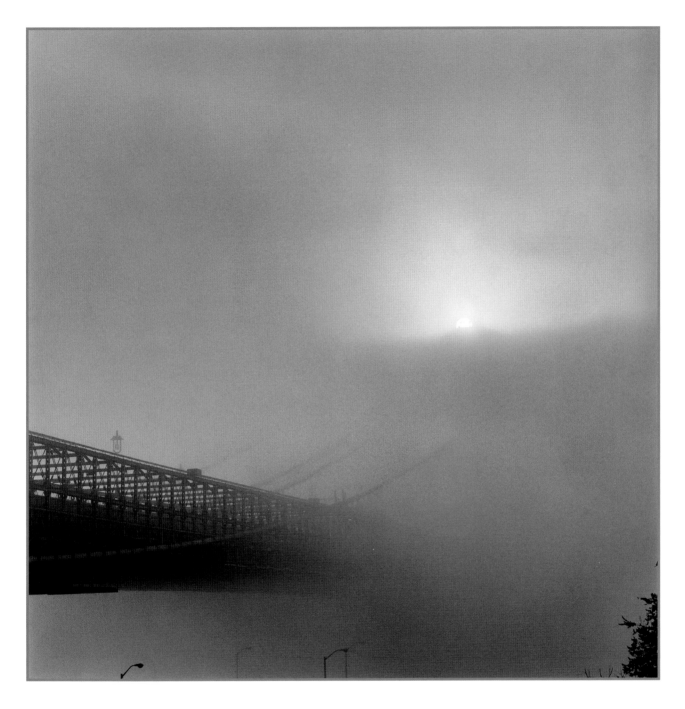

Figure 8. Fog and sun over the Brooklyn Bridge, 1994.

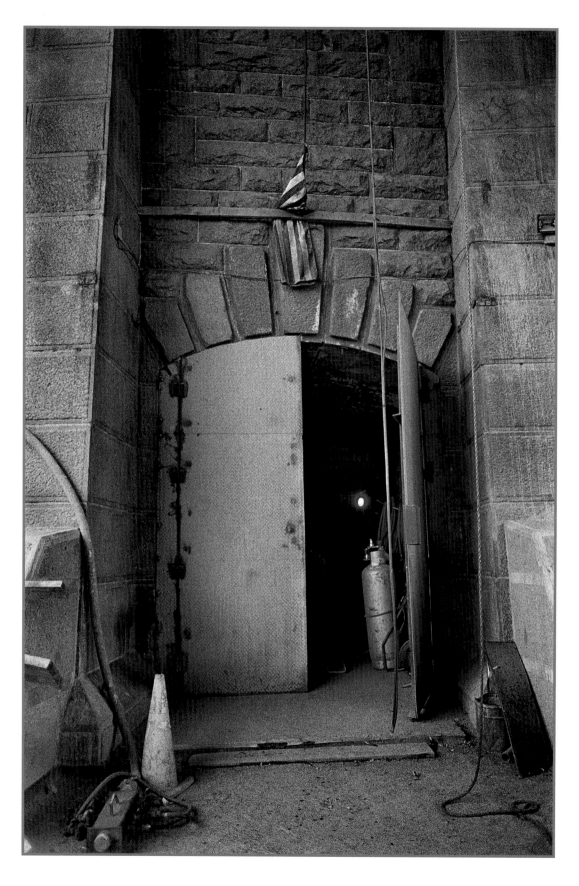

Figure 9. Entrance to the approach on Pearl Street, 1999.

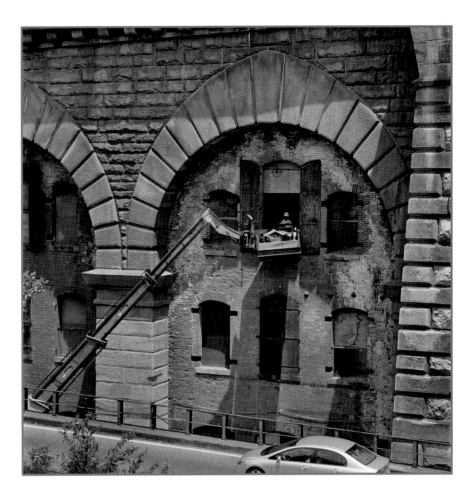

Figure 10. Open shutters and construction crews in interior of approach, 1999.

One day in the late spring of 1999, while walking under the roadway, I noticed that a steel door that was usually bolted shut was now ajar. I had been curious about the inside of the bridge for years, so I pried open the door.

The blinding afternoon light made it difficult to see into the darkened doorway. One thing was for certain: a cool, damp, and musty smell from inside made it feel like a tomb. Above the door, a worn out American flag that was turned upside down was positioned above the entrance.

I returned home, excited with the thought of venturing inside with my cameras; remembering that months before, local newspapers reported that the Brooklyn Bridge was in serious jeopardy and "needed a fix."

The interior of the bridge was off limits to the public, but after three months of persistent phone calls to city managers, my request was reluctantly approved. I could explore the inner sanctum of the bridge on several conditions: to enter at my own risk and not to speak with the press about what I saw. The city gave me a window of two months to work.

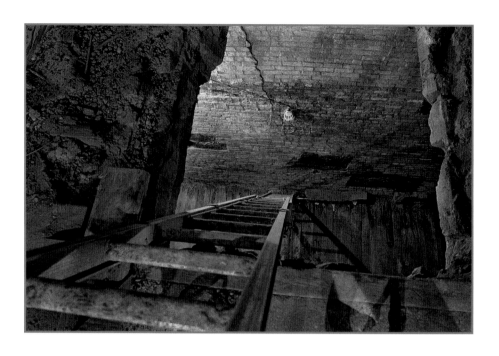

Figure 11 a. Ladder leading down to the sub level of the Brooklyn Bridge, 1999.

I showed up at a makeshift office, located in a trailer next to the bridge. The foreman gave me a hard hat and an industrial flashlight, then he designated one of the construction workers, "Big Mike," to escort me. As we walked through the same open door that I had peered into months before, groups of laborers, carrying tools and safety gear, were going in and out. With a rush of excitement, I was about to explore the depths of the Brooklyn Bridge.

Following my escort through the metal entrance, my eyes adjusted to the void illuminated only by a few construction lights. The smell of mildew and choking dust intensified as we continued further in.

I wrapped a handkerchief around my nose and mouth, following my guide who pointed with his flashlight to a large hole in the ground, which seemed to reach down to at least fifty feet. The long ladder, placed without any reliable support, was leaning to one side of the hole. Descending the ladder first, "Big Mike" shouted: "Follow Me." Carrying a large knapsack of precious photo equipment on my back, I climbed down the ladder which swayed with each step. I convinced myself to look at one rung at a time, which was the only way to survive the descent to the bottom. When we touched solid ground, my guide remarked: "OK, Kid, you're on your own." Then Mike scrambled up the ladder and returned to work. That was that. The tour was over.

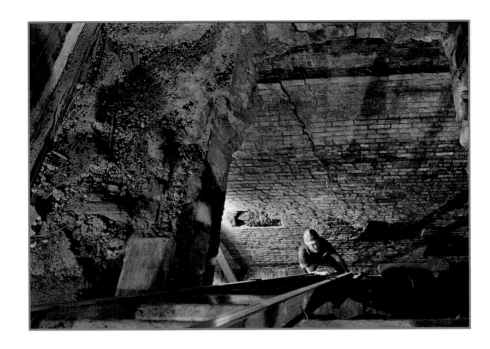

Figure 11 b. Ladder to the sub level, with "Big Mike," 1999.

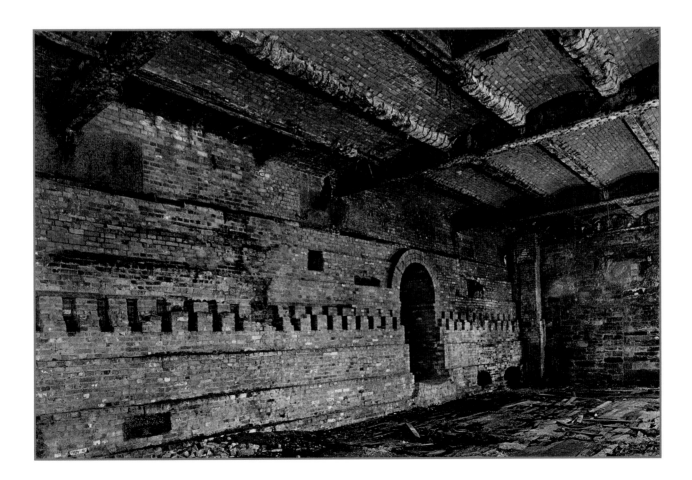

Figure 12. Subterranean level of the approach.

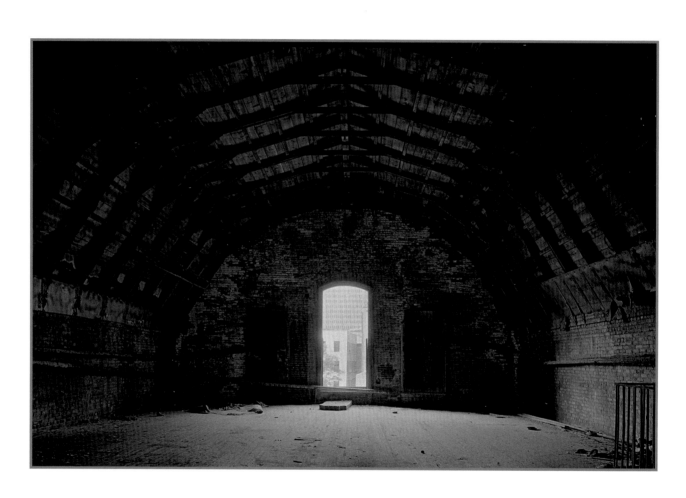

Figure 13. The "Theatre," interior of the approach.

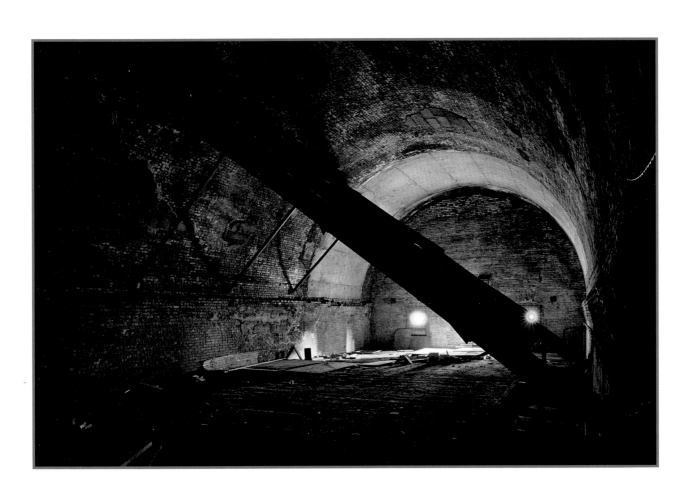

Figure 14. The "Serra Room," interior of the approach, 1999.

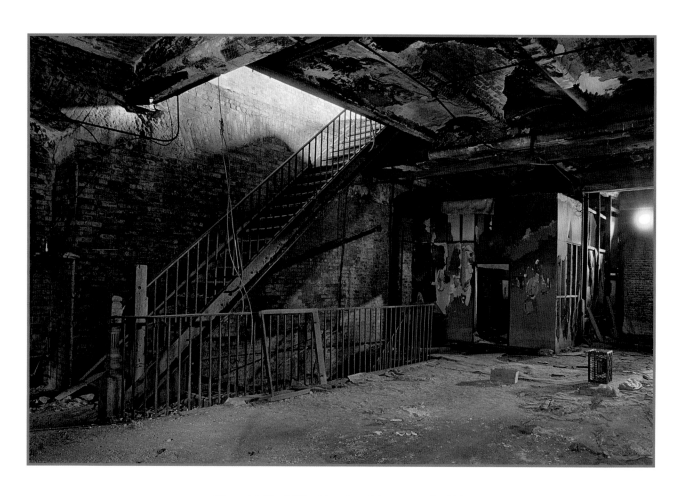

Figure 15. The "Office," interior of the approach, 1999.

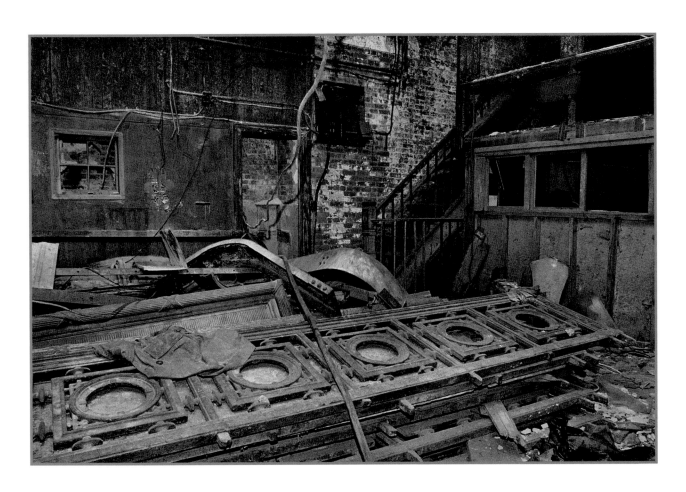

Figure 16. The "Titanic Room," interior of the approach, 1999.

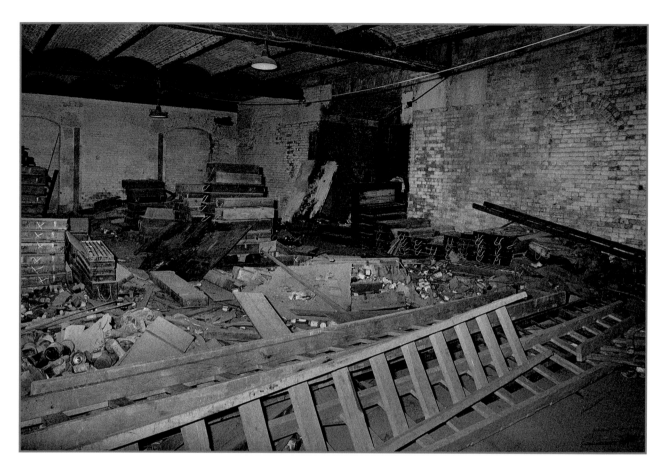

Figure 17. Debris on the ground floor of
the approach, 1999.

I was told to be mindful of the fragile floor boards, many
of them so weak and rotted that falling through was a strong
possibility. Each plank had to be tested with single steps.
Finding a secure spot, I assembled my camera and tripod
in front of a large archway, which reminded me of Roman
catacombs. While standing in this enormous subterranean
space, I noticed a series of tunnel entrances leading to points
unknown. There was a deathlike quiet, in spite of construction
activity and noisy traffic moving above.

Working in complete darkness, I made a series of
time exposures to determine how much light was required
to capture an image. Several hours later, I packed up my gear
and retraced my steps, up the long ladder and out the door
with the upside-down flag affixed overhead.

After testing the film in my darkroom on the weekends,
I settled into a work routine, shooting eight hours a day, three
days a week.

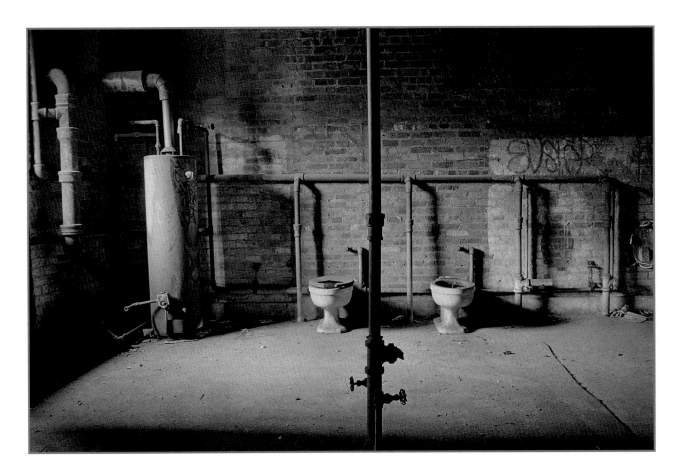

Figure 18. Bathroom, interior of the approach, 1999.

In the next few months, I learned about the netherworld of the Brooklyn Bridge. The faltering stairs led like mazes throughout the interior where, surprisingly, each eerie space was distinctly different.

I attached names to each room that I entered. One of the chambers filled with hand-cast iron railings I named the "Titanic Room." Another cavernous interior that revealed long steel beams fastened from the top of the ceiling to the bottom of the floor became the "Serra Room." It seemed that the iron beam was holding up the roadway. Yet another enclosed area, filled with broken fixtures and peeling sheet-rocked walls I named the "Office." In the "Theatre," streaks of daylight sneaking through cracks in the sealed windows accentuated the melancholy and reminded me of a stage set.

The detritus strewn about included pornographic newspapers, someone's social security card, soil samples packed in tiny jars (meticulously labeled and housed in

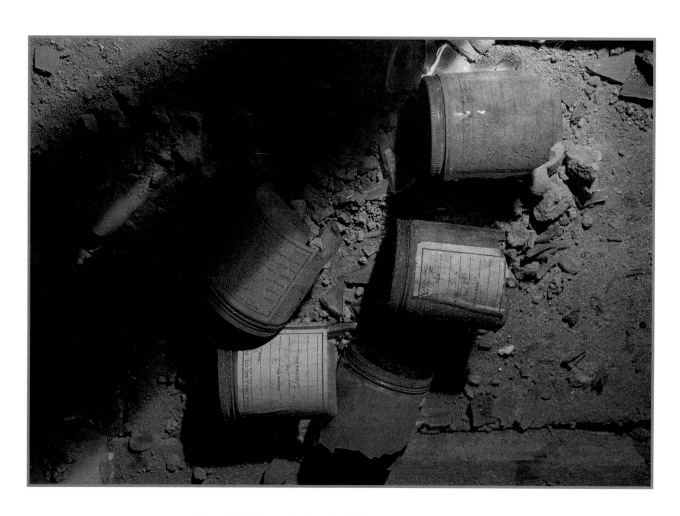

Figure 19. Soil samples, interior of the approach, 1999.

Figure 20. Broken 45 rpm record (lessons in French language), interior of the approach, 1999.

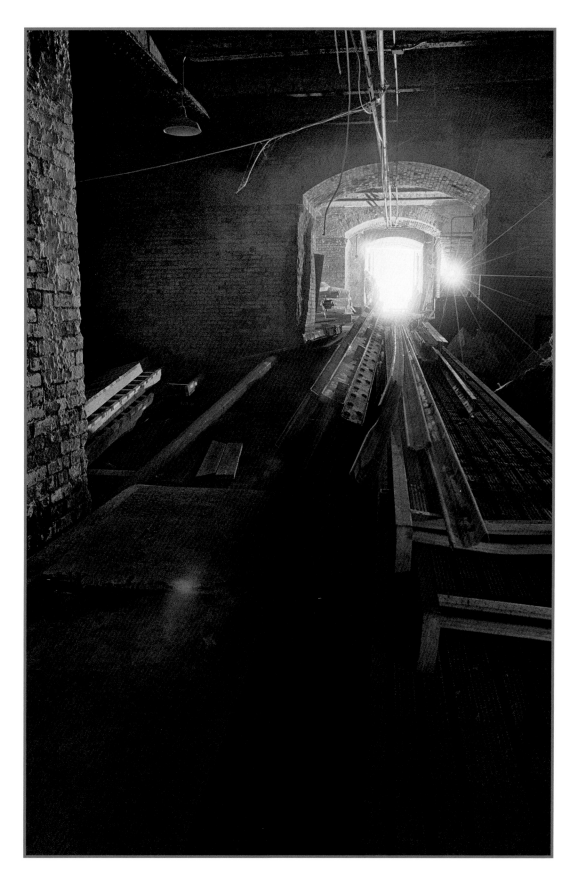

Figure 21. Tunnel inside the approach leading toward the outside entrance, 1999.

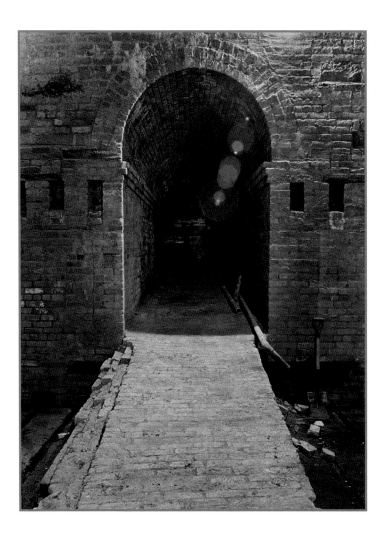

Figure 22. Tunnel inside the approach leading to points unknown, 1999.

wooden boxes that could be mistaken for coffins), and several century-old whiskey bottles.

Homeless people had used the inside of the Brooklyn Bridge as a place of refuge for a long time. Deep within the interior, they left behind artifacts, including soiled clothing, broken 45 rpm records, and, most shocking, a makeshift basketball court on the top floor!

Surprisingly, one afternoon, as I emerged from the darkness to the traffic on Pearl Street I looked up and noticed a plaque, fastened to the outside wall (of the stone approach). Obscured by scaffolding, the plaque ironically read:

THE FIRST PRESIDENTIAL MANSION NO. 1 CHERRY ST.
OCCUPIED BY GEORGE WASHINGTON
FROM APRIL 23 1789 TO FEBRUARY 23 1790.

After weeks spent inside the hidden spaces, I was no longer apprehensive. Instead, the interior became an isolated place of safety and meditation.

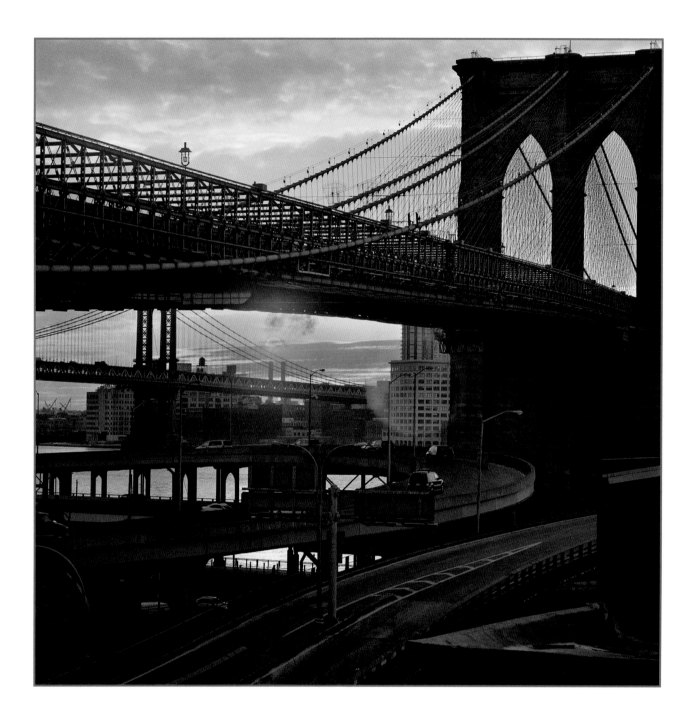

Figure 23. View from the north window, 2004.

One Friday in the late afternoon, I lost track of time. The workers were leaving for the day and were about to close the large metal doors behind them. I hurried back to the entrance just in time.

What would it have been like to be locked inside the Brooklyn Bridge for the weekend?

The beauty of the bridge from outside contrasted starkly with the sad, abandoned interior. What were these spaces intended to be used for?

In search of answers, I visited the Rutgers University Libraries in New Brunswick, New Jersey, the stewards of the Roebling Family Collection.

The archivist rolled out a cart filled with boxes, among them there were several labeled: "JAR," short for John Augustus Roebling, the designer of the Brooklyn Bridge. The boxes contained letters, manuscripts, log books, business records, photographs, drawings, and notebooks.

As I pored over the letters, notes, and records, I was struck by Roebling's handwriting; his cursive penmanship was a study in perfection. German-born Roebling emigrated to America at age twenty-five. He compiled his transatlantic impressions into a book entitled, *Diary of My Journey from Muhlhausen in Thuringia via Bremen to the United States in North America in the Year 1831.*

The young Roebling wrote like a Romantic poet: "The play of the water and the howl of the wind provide entertainment for me. One easily becomes accustomed to the sight of the waves, which like great wild animals, often seem to leap upon the deck as though to devour the ship, but remain satisfied, however, with giving it such a cuff in the ribs that its wooden frame groans in every joint."[2]

His notebooks showed hardly any white space; each centimeter was filled with meticulous notations and calculations. The contents ranged from delicate pencil drawings after ancient Greek sculpture to plans for a suspension bridge over the English Channel!

His curiosity was endless. There were pages and pages of lined blue paper whereon Mr. Roebling's "Theories of the Universe" explored, for anyone that could wade through it, the nature of Matter versus God. Roebling's philosophy was imbued with the belief that all human endeavor was by its nature, spiritual.

His ledger books from Saxonburg, the community he founded in Pennsylvania, showed Roebling to be an impeccable accountant. One sheet of the ledger recorded the cost of educating his first-born son Washington, down to the last penny. John Roebling also noted, disturbingly, that he expected to be reimbursed when his son reached adulthood.

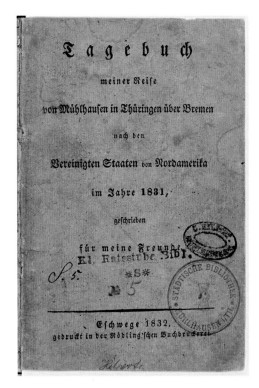

Figure 24. Cover of John Roebling's "Tagebuch" (Diary) from 1831, Mühlhausen State Archives, Germany.

Figure 25. Detail of John Roebling's notations for a wire rope machine, February 1863.

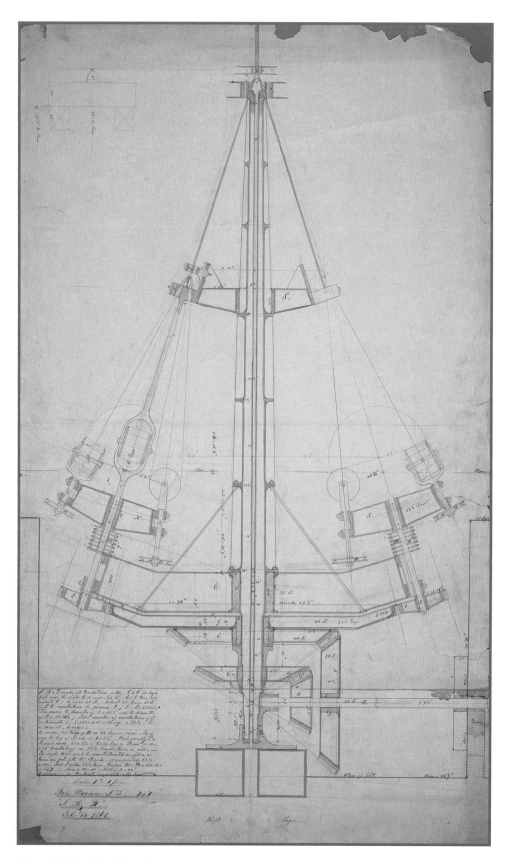

Figure 26. John Roebling's drawing for a wire rope machine, February 14, 1863. Courtesy of Roebling Collection, Institute Archives and Special Collections, Rensselaer Polytechnic Institute.

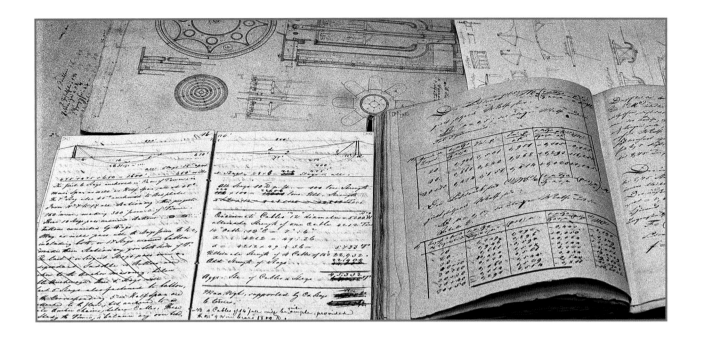

Roebling's vast archive included numerous patents for the manufacture of wire rope and his invention of machinery for its production. From these drawings, one could trace the history of wire rope by viewing the evolution of the machinery he designed to produce it: from a crude mechanism used in a field to sophisticated complex machinery that only a brilliant mind like Roebling's could design.

Going through boxes of business invoices and documents collected from his factory in Trenton, New Jersey, I discovered that Roebling's company, John A. Roebling's Sons, would serve to catapult American technology into the twentieth century. Their wire rope would be incorporated into elevators, telephones, electrical grids, oil well rigging, transatlantic cables, and equipment used in heavy mining construction among numerous other technologies. Beyond the turn of the century, Roebling's wire rope would be used in the wings of airplanes, in skyscrapers, and many new

Figure 27. John Roebling's various calculations and drawings. Courtesy of Special Collections and University Archives, Rutgers University Libraries.

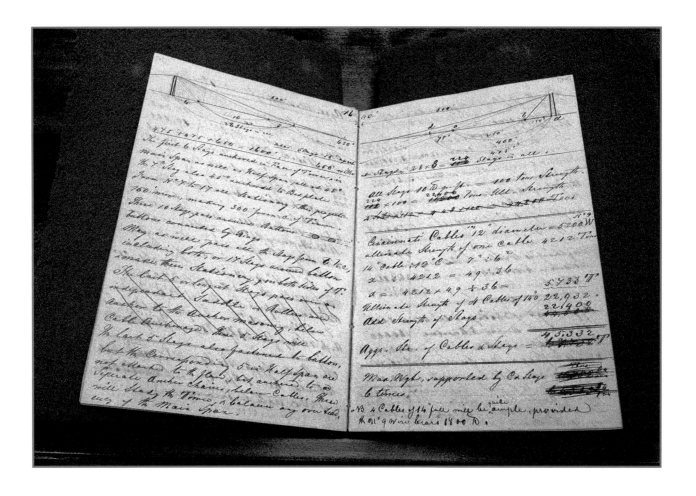

Figure 28. John Roebling's notebook with the first calculations for the East River Bridge.

suspension bridges, most notably the George Washington Bridge and Golden Gate Bridge.

Most thrilling was a small notebook, yellowing and brittle to the touch, with the title, "John A. Roebling 1867 East River Br." Within its pages, Roebling envisioned a span across the turbulent East River. He entered empirical calculations and sketches with a marked self-assuredness as he worked out each new detail of his design. Holding this work in my hands, my heart beat faster. Roebling, it seemed to me, was a latter-day Leonardo Da Vinci. It was at this moment that I first considered the magnitude of his genius.

Although I left that day learning nothing about the mysterious spaces inside the bridge, my attention turned quickly to greater questions about the principal creators of the Brooklyn Bridge.

INSIDE THE BROOKLYN BRIDGE

Years later, I escorted the writer Phillip Lopate inside the Brooklyn Bridge. He was researching material for his upcoming book, *Waterfront*. We crawled through my "secret entrance" and discreetly perused some of the spaces that I had previously photographed. I shared my notes with him.

John Roebling had planned the largest of the vaulted interior spaces to be used as a market hall which would "sooner or later supersede the old Fulton market." Protected by fortress-thick walls of secure space, the subterranean interiors, as Roebling envisioned, were to be used for federal treasury vaults, storing gold bars and other currencies for the investors and bankers on Wall Street.

Instead, the spaces were adopted for light industry and warehousing. A Department of Bridges Report in 1898 listed a rent roll of twenty-eight tenants for the spaces with purposes such as cold storage, the storing of iron machinery parts and junk, radiators and lamps, barrels of wine, a leather and tanning factory, a print shop, a stable, grocer's supplies, a cooperage, and a ship chandlery. The last business to be listed was the Hide and Skin Trucking Corporation, which moved out in the early 1970s.

Figure 29. Vaulted interior, 1999.

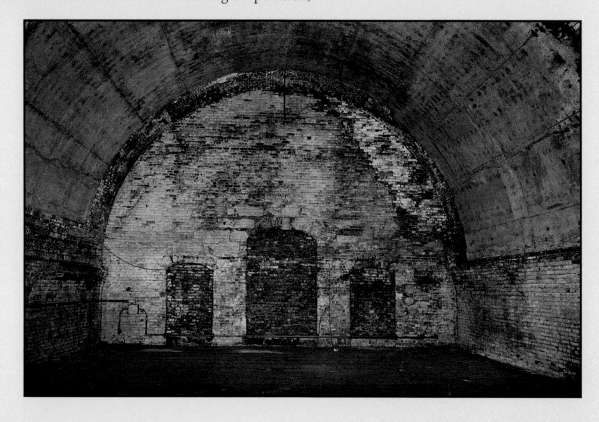

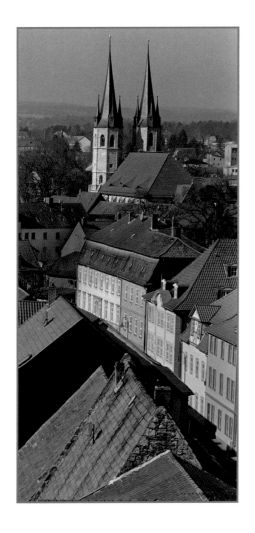

Figure 30. View of Mühlhausen from Divi Blasius Church, 2014.

Figure 31. Street in Mühlhausen, 2014.

Johann August Roebling was born in 1806 to Christoph Polycarpus and Friederike Röbling in Mühlhausen, Thuringia, a German duchy, then part of the Holy Roman Empire. That same year, the empire fell to Napoleon's armies, inaugurating Germany's entry into the modern era.

Impenetrable stone walls wound like a snake around the ancient town of Mühlhausen. Built in the Dark Ages as the best defense against invaders, the walls remained a powerful reminder of the ancient past. They also served as metaphor: Polycarpus perceived the surrounding walls as protection while Friederike felt constrained by them.

> During its years of peaceful slumber there lived in Mühlhausen a well-liked, easy-going burgher named Christoph Polycarpus Röbling. . . . He was a tobacconist by trade, preparing his own stock with the help of his apprentices. Phlegmatic, unambitious, contented, he enjoyed the pleasant scene of his native town, the friendly greetings of his fellow townsmen, his tall

Figure 32. Friederike's wall, 2014.

stein of beer, and his long pipe of tobacco. . . . Distant echoes of political upheavals and military turmoil left him unmoved. . . . Contentedly his gaze would travel over the peaceful scene: the cobbled pavements, the arched doorways, the dormer windows, the steeply gabled roofs, and the ancient church spires reaching skyward above the housetops. . . .

But his wife, Friederike, five years his senior, was of a different mold. Alert, ambitious, grimly determined, she rebelled against the dull, unprogressive life that her lethargic husband found so profoundly satisfying. To her, Mühlhausen was a prison. Walled in by custom and complacency, provincialism and poverty, she rebelled against fate. Chained to a treadmill existence, and facing the blankness of drudgery and despair, she beat in vain against the walls.[3]

Friederike's most dominant characteristic was that of a controlling, outspoken wife which could have won her a seat on the ducking stool (according to her grandson, during his visit to Mühlhausen in 1867). This mediaeval public water punishment was administered to wives who rebelled against their husbands.[4]

Figure 33. Outside wall, Mühlhausen, 2014.

(opposite top and bottom)
Figure 34. Inside wall, Mühlhausen showing the spires of St. Jacob's Church, 2014.

Figure 35. Exterior wall, Mühlhausen, 2014.

Friederike dreamt of something better for Johann, the youngest of her five children. From an early age, Johann demonstrated an intellectual curiosity, nervous energy, and emotional intensity similar to her own. Determined to get her son a first-rate education, Friederike managed to portion the small family income to that end.

At the age of fifteen, Johann was sent to the town of Erfurt to study with the eminent mathematician, Dr. Ephraim Solomon Unger. The young boy was tutored in the Greek classic tradition, learning geometry and drawing. Within a period of two years, Roebling was awarded a surveyor's certificate allowing him admission to the renowned Royal Polytechnic School in Berlin.

At the academy in Berlin, Roebling engaged in a rigorous academic program including the study of architecture, hydraulics, and bridge building. Note taking during lectures was required of all students. Roebling worked on his notebooks from morning until night. It was a sizable task to

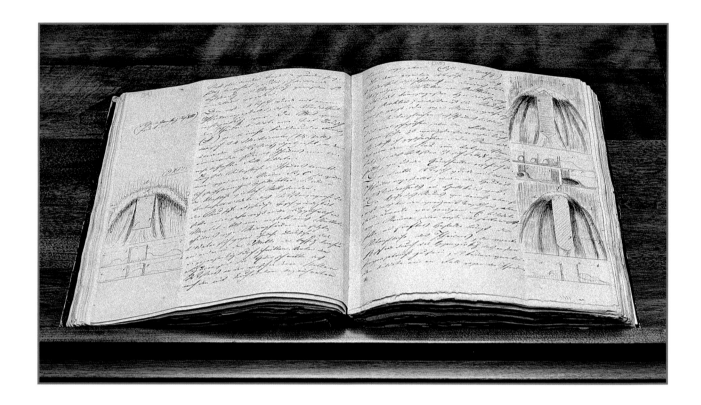

Figure 36. John Roebling's student notebook. Courtesy of Special Collections and University Archives, Rutgers University Libraries.

assemble them. Similar to Da Vinci, these notebooks would later become evidence of his thoroughness in problem solving and ceaseless curiosity.

Roebling was among hundreds of young liberals, influenced by the political upheaval in France. They were swept up in the "zeitgeist," their lives under siege from their own autocratic regime at home. Roebling, along with other students, crowded the lectures of the most provocative philosopher of the time, Georg Wilhelm Friedrich Hegel.

By the time Hegel assumed the chair of philosophy at the University of Berlin, he had written and published volumes of work, complex doctrines on self-realization and the supremacy of reason. He challenged his followers to consider a radical new definition of freedom and to trust with an unyielding faith in one's conclusions. Students crowded his lecture hall, straining to hear every word from the notoriously soft-spoken philosopher, in the words of historian Steven Stoll, "How he hacked and coughed, stopped to swallow in the middle of sentences and generally struggled to get a word out . . . but the audience was enthralled."[5] Hegel's impassioned ideas may have unleashed in Roebling a lifelong tendency to hubris and intolerance of other people's ideas.

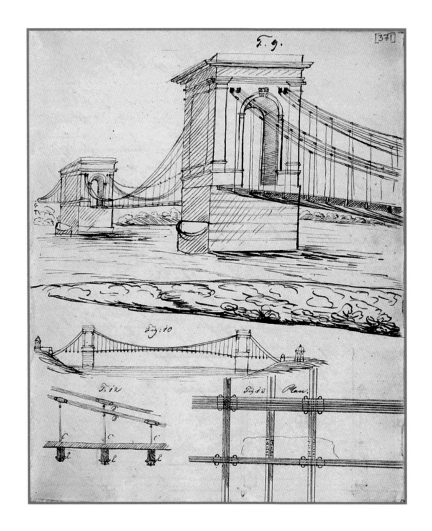

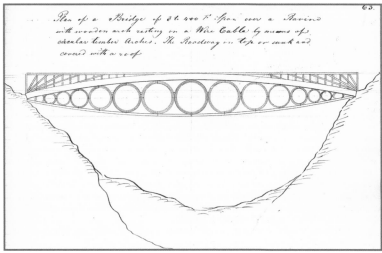

(top) Figure 37. Roebling's drawing of Hammersmith Bridge, London.
Courtesy of Special Collections and University Archives, Rutgers University Libraries.

(bottom) Figure 38. Plan of a wooden bridge, supported by wire cables.
Courtesy of Special Collections and University Archives, Rutgers University Libraries .

As part of his studies, Roebling traveled to the town of Bamberg to see "the miracle bridge," the first bridge of its kind using iron chains to suspend the span. He took copious notes and drew the bridge from various angles, adding his own details for its improvement.

There is no explanation as to why Roebling left school in 1825. He was obliged by institutional practice to work as a government road surveyor, a dead-end job he held for several years.

Roebling continued to produce proposals, considering a thesis to complete his second exam. From 1827 to 1828, he ambitiously created two more suspension bridge proposals. Although the work was praised, none of his proposals ever saw the light of day.

Disheartened by uninspiring employment and growing frustration with a system that suffocated his skills and imagination, Roebling returned to Mühlhausen.

On a fateful day in 1830, Roebling met an old friend, Johann Adolphus Etzler walking down a street in Mühlhausen. Hardly recognizable, Etzler, more than a decade older than Roebling, was now middle aged, short, somewhat muscular, with a "massy head" and protruding brow.[6]

Etzler had just been released from jail and was eager to share his experiences with Roebling. Still agog with tales of his journeys, Etzler recounted tales of finding virgin lands and the "true freedom" awaiting on the unexplored continent of America. Etzler told Roebling that he had already spent several years in Pennsylvania where he tried to establish a utopian settlement. Upon returning home from America, Etzler explained, he had urged others to emigrate with him, but his proselytizing landed him in prison for treason. "Imagine him standing in the streets of Mühlhausen, clothed in the same reeking coat he wore in the hold during his passage, gaunt and bearded, secretly conspiring with artisans, preaching about Pennsylvania to anyone who would listen. Prussian police arrested the street rat without a warrant and threw him in jail."[7]

Roebling fell under Etzler's spell and they collaborated, risking imprisonment and torture, to form the Mühlhausen Emigration Society. To inspire and attract future settlers, they

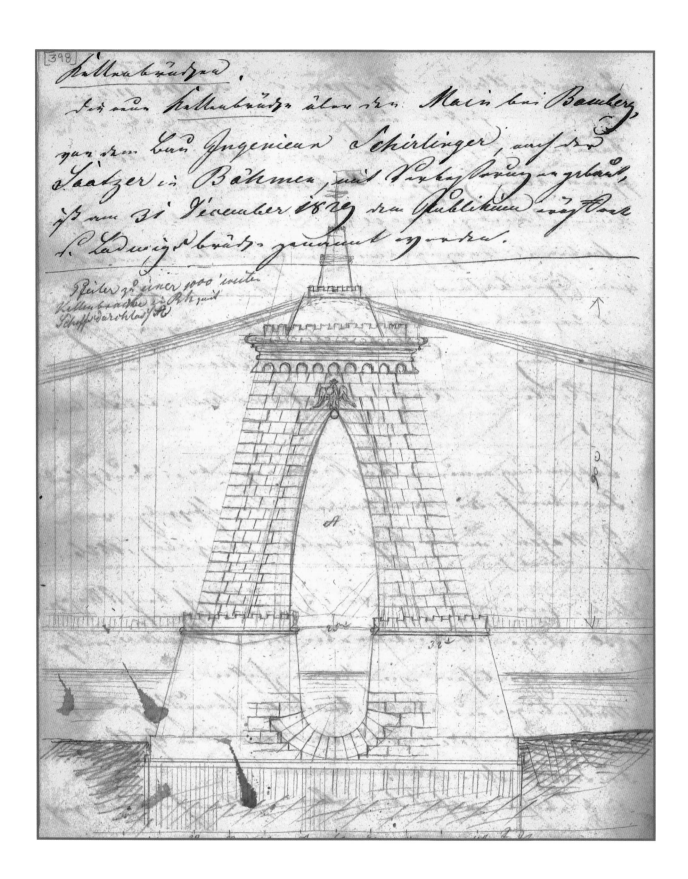

Figure 39. John Roebling's notebook with proposal for a 1000 ft. suspension bridge over the Rhine River, 1830.
Courtesy of Special Collections and University Archives, Rutgers University Libraries.

secretly wrote and distributed a pamphlet, titled "A General View of the United States of North America, Together with a Community Plan for Settlement."

Roebling prepared for his trip to America. He taught himself English and researched America's vast territories, giving careful thought to different regions where settlement could be possible. He compiled a limited selection of favorite books and magazines to take with him. With his sights set possibly on emigration, Roebling did not submit the final thesis for his engineering degree.

His plan to leave home sowed discord in the Roebling household.

> The mother did not altogether understand what John was doing, but she trusted his judgment, and at least he was getting beyond the walls of Muhlhausen. Polycarpus, on the other hand, could not conceive why anyone should want to make a change. Certainly nothing could lure him to America. There was no telling what the wild Indians might do. Moreover, where in the world could beer like this be found, and what was there in America to compensate for such a loss? Why give up all one's cronies, all the settled comforts and habits and pleasures of life for strange adventuring in a wilderness, among savages and foreigners? Besides, he had heard that new and surprising things were constantly happening in the United States. Everyone knew there was no danger of anything new happening in Muhlhausen.[8]

On May 11, 1831, Friederike and Polycarpus said good-bye to two of their sons, Johann and Carl, who left Mühlhausen for America. Their sons were never to return.

Figure 40. Street in Mühlhausen, 2014.

Figure 41. Roebling's view of America #1, 2015.

Figure 42. Roebling's view of America #2, 2015.

Figure 43. Mühlhausen landscape, 2014.

MÜHLHAUSEN, GERMANY

Approaching Mühlhausen on a winter evening, I reached the central square near the celebrated Divi Blasius Church.

This was a town of ancient dwellings. Many that survived from the Middle Ages were built from mud, straw, stone, and wood. Each house told its own story evoking the grim history of the region.

The night of my arrival, I wandered the dimly lit streets, following stone walls that led like mazes to a town deeper in. I was searching for the fabled house: the birthplace of Mr. John Roebling.

Then I found it.

Roebling's birthplace was situated on a nondescript street. Polycarpus's memorable tobacco shop located on the ground floor was now a melancholy empty storefront. I walked through a darkened vestibule to a door which had a name on the buzzer, indicating that someone was living on the second floor.

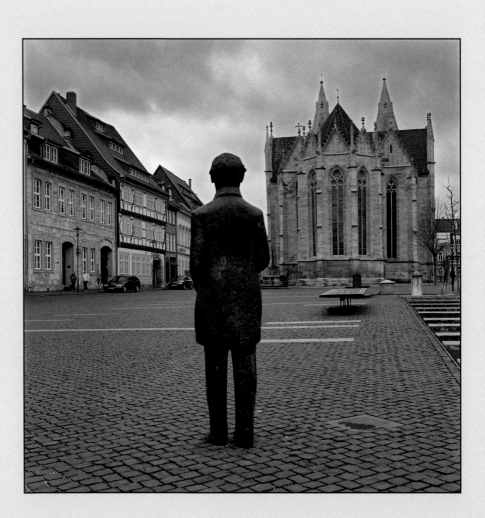

Figure 44. Statue of John Roebling looking toward Divi Blasius Church, 2014.

Figure 45. Birthplace of John Augustus
Roebling, Mühlhausen, 2014.

Once upon a time, it was Friederike Roebling's household, where she cooked, cleaned, and saved her pfennigs while planning her son's future and his path to greatness.

I was dumbfounded. Surely this could not be possible. Surely this could not be the place where the mythic tale of the Brooklyn Bridge had its roots!

The following day, I returned to the Roebling house and watched as a school group passed by. The teacher, raising her voice, failed to garner attention from her distracted group of teenagers as she pointed to the commemorative plaque dedicated to Mr. Roebling situated above the storefront.

I walked across the square, where a free-standing statue of Roebling was facing the Divi Blasius church. Roebling's stance was fixed in time, as if he were to be studying the Gothic lines of this fabled church into perpetuity.

I was to meet the priest of the Divi Blasius Church at midday. In my imagination the priest would appear tall and austere, his face looking solemn, his sad eyes staring out at the world reminiscent of religious figures from Gothic paintings. Instead, the priest appeared bright, spry, and quite modern. He was dressed in contemporary street clothes and wore glasses.

The priest shared fascinating information about the Divi Blasius Church: that it took 100 years to build it in the twelfth and thirteenth centuries, and that it housed one of the oldest church bells in Germany. He added that the Divi Blasius was made famous because of Bach's stint as official organist in 1707 and John Roebling's baptism in 1806.

The priest remarked that during the winter months, he was compelled to move his congregation to a warmer location.

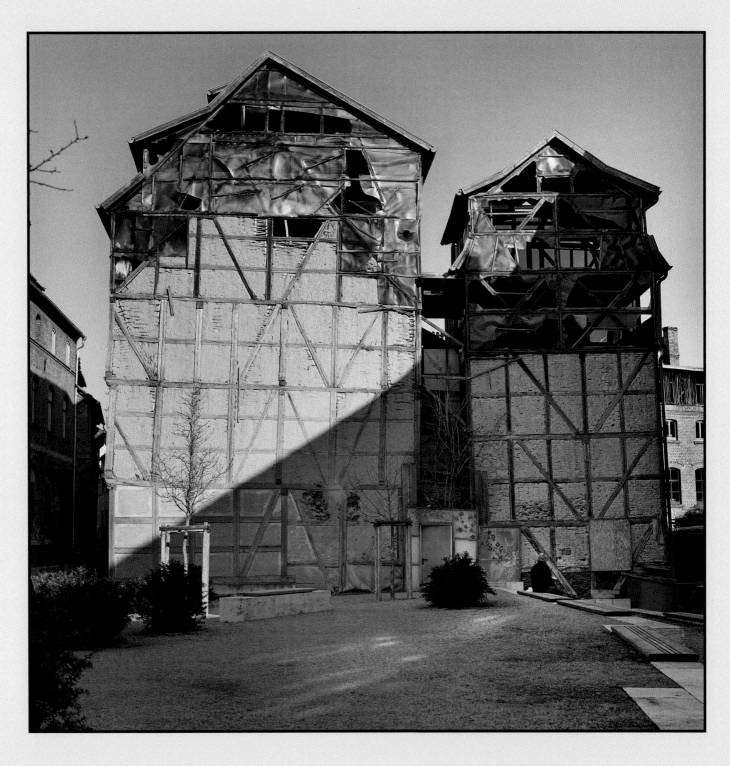

Figure 46. Houses of industry (leather tanning factories from 1700s) converted to current residential dwellings. Mühlhausen, 2014..

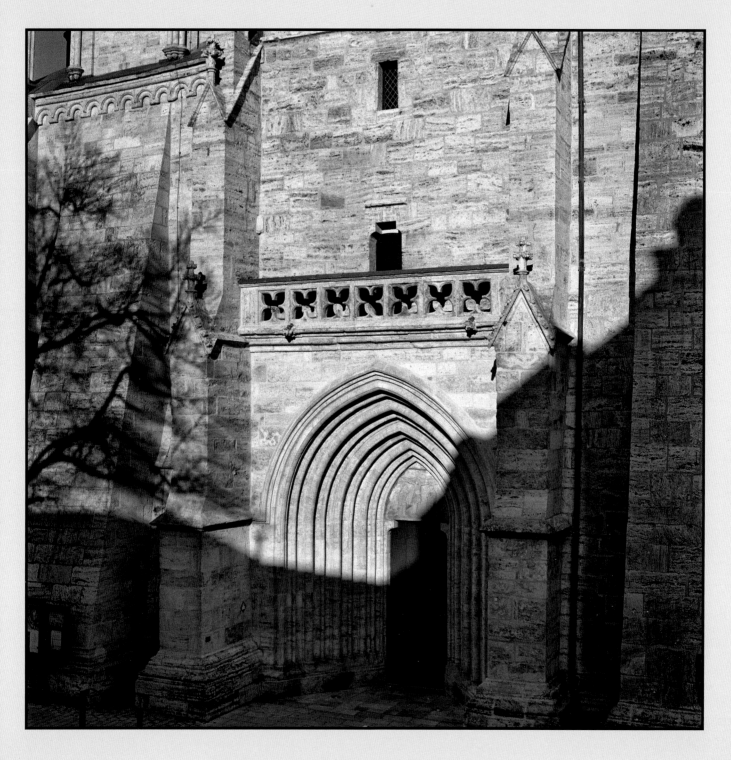

Figure 47. Outside entrance, door to Divi Blasius Church, 2014.

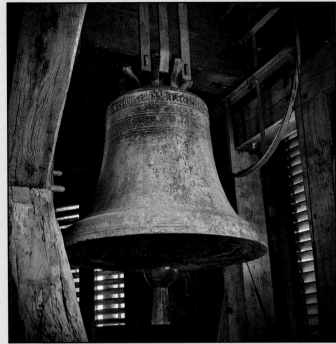

(above left) Figure 48. Interior passageway to fire watcher's quarters, 2014.

(above right) Figure 49. The third oldest church bell in Germany, Divi Blasius Church, 2014.

Nevertheless, he handed me the key to the church, adding that the custodian, a sexton was available to assist me. He then hurried on to his next appointment.

I opened the wooden door to the church and then locked it behind me. For several hours, I walked around the interior, noticing statues and relics of religious figures unknown to me from German history. Later in the day, the sexton arrived.

He suggested a plan to climb to the top of the bell tower.

I followed him through an arched entrance and ascended a spiral staircase. The stone steps were worn from centuries of foot traffic. On the first landing, we passed a ledge filled with fragments of stone reliefs that were once church ornaments. I followed him up a spiral ladder becoming narrower and steeper the higher we climbed. Each landing led to another austere space. One interior housed plaques leaning against the massive stone wall; inscribed were the names of fallen soldiers from World War II.

As we continued our ascent, we crossed through a passageway into a darkened chamber with an incredible view through open columns of the town below. The sexton explained that a man had lived here centuries ago, designated with the task of ringing the church bells to warn the townsfolk in the event of a catastrophic fire.

The following day I returned to the church and noticed the door to the church was unlocked. When I entered the nave, an organist was practicing some of Bach's cantatas on the pipe organ located high above the entrance. Walking toward the altar I noticed the

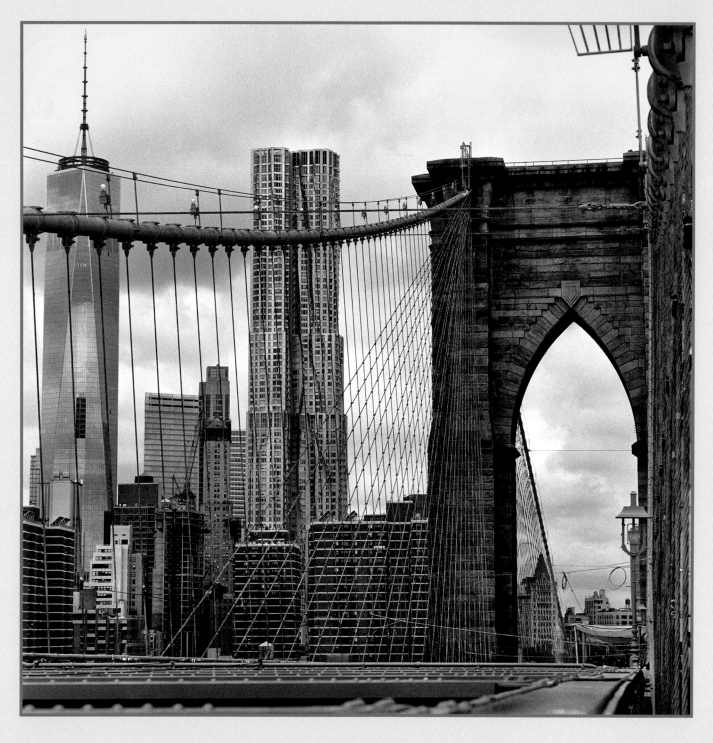

Figure 50. View of the New York skyline from the Brooklyn Bridge, 2017.

(above) Figure 51. Priest's Door, Divi Blasius Church, 2014.

(right) Figure 52. A Walk Across the Bridge, 1997.

door to the priest's chamber. Similar to the other prominent Gothic elements of this beautiful church, the door's pointed arch was meant to reach toward heaven. I could not help but think of John Roebling's towers of the Brooklyn Bridge, pointing toward paradise, invoking his spiritual quest.

When the colonizing group arrived in the German seaside town of Bremen, the brothers learned that their ship had already left with half their number on board, a sign of future disharmony. Roebling took charge and secured another ship, the August Edward, for their voyage.

On board, Roebling's preoccupation with problem solving left him at odds with the captain as he campaigned to improve the sanitary conditions of those traveling in steerage. Roebling was also intrigued by the mechanics of sailing; fascinated with "the stays," the diagonal rigging, which held

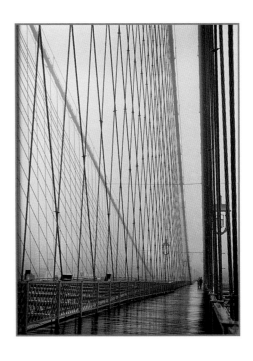

the mast in place against the forces of the wind. Years later, these diagonal stays would become the signature of a Roebling bridge.[9]

After eleven weeks at sea, which was longer in duration than the voyage of Christopher Columbus, the pilgrims disembarked at Philadelphia. Optimistically, Roebling recorded in his diary nuanced observations of American customs, including his first experiences while staying at a boardinghouse: "At each meal, morning, noon and evening, the table is set in the English custom, with coffee, tea, butter, corn bread, meat, eggs, roast meat, salad, and the like. The landlady pours the coffee and does nothing else, but simply gives the invitation 'Help Yourself.' Nothing further is served. The Americans set to quickly, eat even more quickly, and leave the table without having said a single word."[10]

Roebling and Etzler quarreled continuously about everything onboard the ship that they decided to part ways. Etzler took his group of followers west to Ohio. The Roebling brothers decided against traveling south and chose Pennsylvania as their destination. "In general we have been frightened away from the south by the universally obtaining system of slavery . . . how hard it would be to accomplish anything with free German workers in a place where all work is done by a despised race of men, namely the blacks."[11]

Taking the few remaining loyal Germans with them, the pilgrims traveled a grueling three hundred miles aboard canal boats and were transported by wagons over hilly terrain with barely passable roads until they reached Pittsburgh. Roebling's brother Carl had contracted malaria on the journey, reinforcing the decision to settle north in Butler County. Without any firsthand knowledge of farming, Roebling purchased approximately several thousand acres for about one dollar and fifty cents an acre with money entrusted to him by family members and friends.

It took many months for Roebling to persuade others from his hometown to make the trip and invest in the settlement. Little by little, a few Germans came, and in the spring of 1832, John Roebling took to his drafting tools and

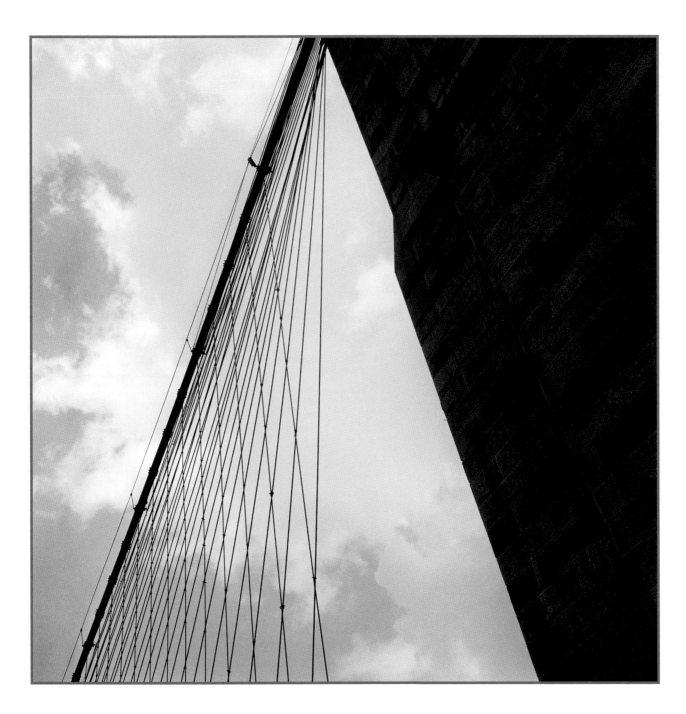

Figure 53. Cable studies, 2009.

began his first project in the new land: to construct a utopian community named Germania.

He designed the village, changing its name to Saxonburg. John's skills as an architect, draughtsman, surveyor, civil engineer and town planner were formidable. With great accuracy, he laid out streets and lots. With members of his fledgling colony, he built roads and wells, dug ditches, erected houses, and constructed a church of his design.

Among those who Roebling convinced to come was Ferdinand Baer, a close friend from Mühlhausen. To further the utopian ideal, Baer built a communal house where new colonists could share food and conversation and use a common workshop. In a letter to John Roebling, Baer shared his thoughts: "Those who will be employed in the workshop are Mr. Aug. Roebling as draftsman, Baer as head of the workshop, our good man Boettger as finisher and two good journeymen. I will supply all of the carpentry equipment for cabinet-making, locksmithing, wood turning, polishing and the rest. We will all work for the betterment of life for everyone, whilst the others work in the fields and provide for our physical needs."[12]

Roebling began a new life as a farmer. It did not take long for him to discover, to his great disappointment, that the soil was mostly clay and did not lend itself to the cultivation of food crops. He attempted to grow sunflowers, rape seed, mulberry trees, and silkworms. Roebling tried to raise sheep and breed canaries. All his undertakings failed. The utopia that Etzler promoted on a street in Mühlhausen became a faint and distant memory. At this low point in their fortunes, the Roebling brothers learned that their mother Friederike had died from a cholera epidemic ravaging Mühlhausen.

In 1836, Roebling married Johanna Hertig, a soft-spoken young woman whose family had recently emigrated from Mühlhausen to Saxonburg. From the beginning, it was clear they were mismatched. Roebling's personality, a combination of intellectual curiosity, volatile mood swings, and blind ambition stood in contrast to his bride—a humble, shy young woman who spoke no English and had very little education.

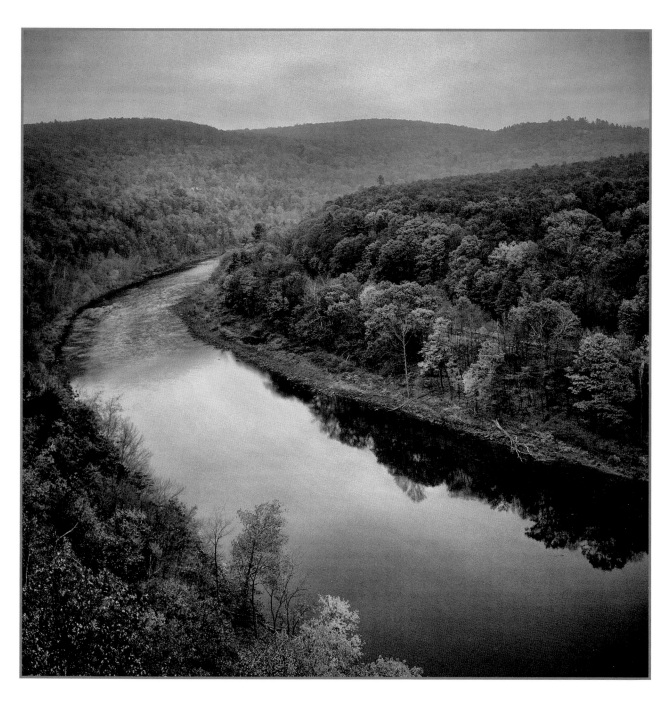

Figure 54. Into the wilderness, 2016.

The following years were filled with change. In 1837, Roebling lost his brother Carl, who died suddenly of sunstroke, plowing in the fields. Soon after, Johanna gave birth to John's first son, Washington. Inevitably, Roebling would now shoulder more responsibility. Confronted with this new reality, his thoughts returned to engineering. In the same year, Roebling anglicized his name (from Johann August Röbling to John Augustus Roebling) and became an American citizen. He also registered as a surveyor with the State of Pennsylvania.

It was a daunting task to look for work. Roebling had absolutely no contacts. He sent letters of introduction and followed every lead. During this time, Roebling was still gaining a small income from the farm although he had no patience for the work. He would often lose his temper. A horse pulling a plow was made to move faster by driving nails into its haunches, or verbal assaults were hurled at potatoes which he perceived to be growing too slowly in the ground. Eventually, his wife Johanna would be tasked to do most of the farm work.[13]

Fortunately, the expansion of the Pennsylvania Canal (a network of manmade inland waterways) coincided with Roebling's search for employment. By the end of 1837, Roebling had secured a job working on the construction of a feeder canal, delivering water from the Allegheny River to the Pennsylvania Canal.

Roebling's enthusiasm for creating new technologies was expressed in his notebooks from this period. The ledgers contain a collection of innovative ideas: designs for locomotives, steam engines, and even a steam-powered motorcycle.

To advance his name and to advocate for a future expansion of the railroad system, Roebling became a regular contributor to the *American Railroad Journal*, the leading engineering publication of the day.

Roebling's self-promotion led to temporary work as a surveyor. In 1839, he began a survey of a railroad route east of Pittsburgh. He traversed one hundred and fifty miles of treacherous terrain, plotting lines through thick woods

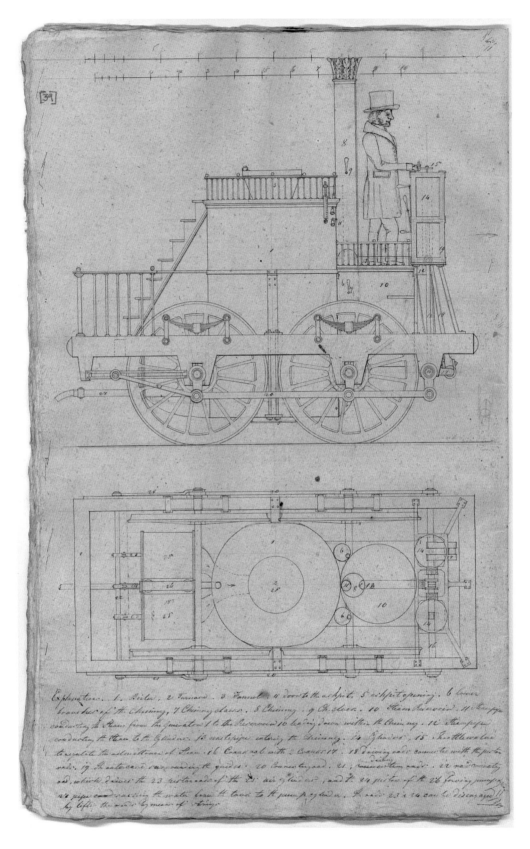

Figure 55. John Roebling's steam engine (from his notebooks).
Courtesy of Special Collections and University Archives Rutgers, University Libraries .

and steep inclines. Roebling successfully executed maps in impeccable detail showing the territory. His surveying work was brought to the attention of Charles Schlatter, superintendent and chief engineer for the Pennsylvania Railroad. Schlatter promoted Roebling to be his assistant. As a result, Roebling's new-found employment took him away from home for longer and longer absences.

While surveying, Roebling became intrigued with portage railroads, a short-lived phase in the development of the national railway system. Because locomotives were not yet powerful enough to carry freight over mountainous terrain and gradual railroad grades had not yet been devised, a heavy load was transferred from a locomotive transport to a portage railroad: a pulley-machine system designed to haul freight over a mountain ridge and then shift it back to a locomotive.

In *American Notes*, Charles Dickens described his harrowing experience of riding a portage railroad:

> On Sunday morning we arrived at the foot of the mountain, which is crossed by the railroad. There are ten inclined planes; five ascending and five descending; the carriages are dragged up the former, and let slowly down the latter; by means of stationary engines; the comparatively level space between, being traversed, sometimes by horse, and sometimes by engine power, as the case demands. Occasionally the rails are laid upon the extreme verge of a giddy precipice; and looking from the carriage window, the traveller gazes sheer down, without a stone or scrap of fence between, into the mountain depths below.[14]

Roebling's inventive mind was ignited by a calamitous portage accident that he witnessed in 1840. When the hemp ropes pulling a heavy load to the top of the mountain snapped, the load slipped backward and crushed two workmen.

Recalling an article about wire rope that he had read in a German magazine, Roebling began to design a new rope product that would be more flexible and longer lasting than hemp.

He corresponded about his work with a fellow engineer, Charles Ellet Jr., who was also intrigued about the potential applications of wire ropes.

Figure 56. Precipice of mountain scouted for the Portage Railroad, Pennsylvania, 2017.

In his pursuit of employment, and with the impression that Charles Ellet was older and more accomplished, Roebling wrote respectfully to Ellet, who was the chief engineer of the Virginia Canal Project: "You will certainly occupy a very enviable position, in being the first engineer who aided by nothing but the resources of his own mind . . . succeeds in introducing a new mode of construction, which here will find more useful application than in any other country."[15]

Roebling published an article on the applications for wire rope in the *American Railroad Journal*. He posed as a "wire bridge expert" arguing that more wire bridges should be built, not by "mere mechanics" but by "the most eminent engineers."[16]

As often happens among competing colleagues, Ellet was incensed and claimed that Roebling stole his ideas. Their tenuous relationship ended and they became life-long rivals, vigorously competing for bridge contracts. Competition fueled their ambition, to the benefit of technological progress.

In 1841, John Roebling was about to receive the contract to build Philadelphia's Fairmont Bridge, America's first wire-rope suspension bridge. However, Charles Ellet, through a purchase of Bridge Company stock, was able to maneuver the contract toward himself. Roebling would later write: "I was well aware that from the time the bridge was awarded to me that Ellet and his partisans were secretly at work undermining and endeavoring to supplant me."[17]

Roebling grew secretive and obsessive, retreating to his workshop in Saxonburg to refine his version of wire rope. He established a ropewalk in the field behind the village church. Hiring townspeople at his own expense, they spiraled, spliced and wound the wire around wooden spools.

During this period, Roebling wrote numerous proposals for the portage railroads. The record shows several letters from W. E. Morris of the engineer's office in Hollidaysburg, Pennsylvania, responding to Roebling's correspondence.

> My report to the board on the subject of wire cables, has just been made. . . . You must have unlimited confidence in its success to warrant you in making the state such a favorable

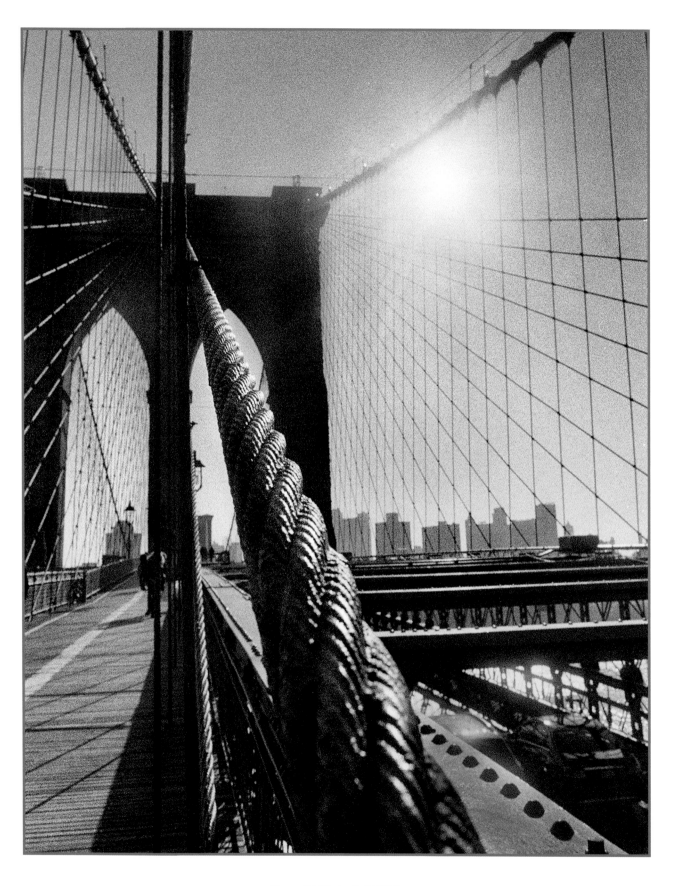

Figure 57. Winter light, 2018.

offer as you propose. And the state or the trade will incur no risk, for even in case of failure the hemp rope can be replaced in a few hours. I hope you get the opportunity of testing your plan, and raising your fame, by proving the utility and durability of metallic threads over vegetable yarns.[18]

After several years of failed tests and with the financial pressure mounting, Roebling was finally convinced of his product's quality. In 1842, he registered his patent and asked his former employer Charles Schlatter to test the wire rope on one of the inclined planes of the Pennsylvania Railroad.

At long last, a successful performance won Roebling his first contract. Demand for the new rope increased and Saxonburg became the center of its production. There, a large crew of his fellow townspeople twisted the wire strands together to form the inch-thick cable. Every eight or ten days a rope was laid, using the outdoor ropewalk and requiring the labor of eighteen men for one or two days. They worked from dawn to dark, while Mrs. Roebling cooked meals over an open hearth, which was an enormous task.

By 1843, Roebling's relentless campaign made him the premier supplier of wire rope for the portage railroad industry. His company grew rapidly and eventually made him a wealthy man.[19]

Roebling's first bridge project was an aqueduct. In 1844, for a prize of one hundred dollars, he entered a competition to build the Allegheny Aqueduct in Pittsburgh. He proposed to build a suspension aqueduct, which was both ambitious and unprecedented in scope. Roebling lobbied passionately for the contract, with the singular purpose of proving his talents. He was the low bidder and won the prize. Charles Ellet, in Europe at the time of the competition, did not bid on the commission.

Acting as both chief engineer and contractor, John Roebling introduced many innovations, such as a cable-wrapping machine that he used for all his future projects. It is not difficult to imagine this determined man, living in a tent by the edge of the river, supervising his team, climbing the

Figure 58. Winter on the river, 2016.

spindly catwalk, and directing the workers and trades people, all the while drinking coffee and eating little. After each long day, instead of resting, he worked late into the night, drawing up plans for the next morning, listing construction material orders, keeping accounts, and planning his crew's work schedules.

Completed on budget and on schedule through severe winter weather, the aqueduct opened in 1845. This suspension aqueduct carried more than two thousand tons of water within the flume, with a steady movement of canal boats, hauled by mules, high over the treacherous waters of the Allegheny River.

Figure 59. John Roebling's aqueduct for the
D & H Canal, Lackawaxen, New York, 2016.

Soon after completing the aqueduct, a fire swept through Pittsburgh and destroyed the wooden Smithfield Street Bridge. Roebling was handed the contract to replace it. Using the existing piers, Roebling completed the suspension bridge in 1846.

Calculating that the remote location of Saxonburg made the shipping of wire rope too expensive, Roebling decided to build a large wire-rope factory in Trenton, New Jersey, in 1849. This East Coast city would also serve as a better base for all engineering work including the new contract to build four new aqueducts for the Delaware and Hudson Canal.

In October 1849, the last wire rope was made in Saxonburg. The loss of the business decimated the town's economy. John A. Roebling never looked back and never returned to the community that he had founded.

Figure 60. Treacherous waters, 2016.

Figure 61. D & H Canal remnants, Highfalls, New York, 2017.

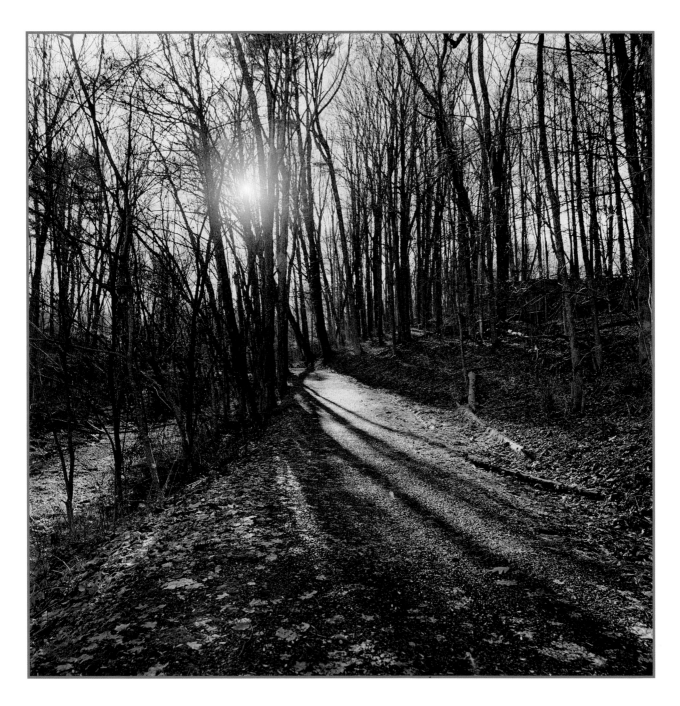

Figure 62. Towpath for D & H Canal, 2017.

The utopian community that John Roebling founded with just a handful of pilgrims still exists. The wilderness town of Saxonburg, located thirty-nine miles north of Pittsburgh, was on my list to photograph. The goal was to find the house that John Roebling built and to visit his wire rope shop where, with determination, he shaped the future of American technology.

Arriving at night during the Christmas season, the flickering, colored lights lining a snowy Main Street were reminiscent of illustrations from fairy tales. The following morning, I followed the same street to the far end, where John Roebling's home was located.

I knocked and stepped inside, noticing the interior had long since been restored, but not to its original state. Its walls, constructed in the early nineteenth century, were covered with plaster. The rooms were cleared of objects that may have been important to the Roebling story.

A woman working at a desk looked up as I began to ask questions. In recent years she explained, the house was converted into office space for the nearby church.

Unable to share information about the Roebling house, she was, however, eager to speak about the ghosts that she heard often, shuffling around upstairs. She pointed to a sliver of exposed wall on the staircase landing, explaining that it was once the sleeping quarters for servants.

I walked up the wooden stairs which continued to the attic. It was dark and empty. Discarded sports items such as helmets, bits of clothing and hockey skates were strewn across the floor.

Afterward, I went to the meadow where the rope walk was once situated and met the curator of the Saxonburg Museum. He was a retired steel mill worker who assumed the position of caretaker of the collection, which included varied examples of village memorabilia.

One object stood out. It was a striking double portrait of original settlers. Written on the back of the double-framed photographs was: "The Sieberts." They were the indentured servants who traveled to America with Roebling. It was exciting to make this historical identification. The Sieberts had lived in Roebling's attic. After they completed their servitude—years of hard work while saving their

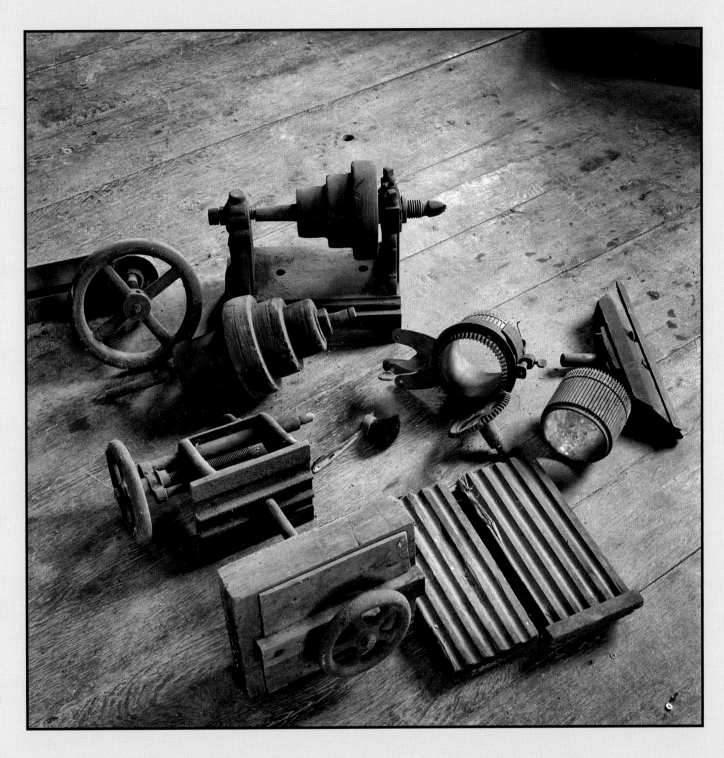

Figure 63. Machine parts from Mr. Roebling's Wire Rope Shop, Saxonburg, Pennsylvania, 2016.

pennies—they acquired a small parcel of land outside of town, Thorn Creek. It was there, years later, that they would strike oil and accumulate great wealth.

At the end of the day, I pressed the curator to open the wire rope shed, which was off limits to the public. Camera in hand, I was excited to see what I could find. The door swung open and I was taken aback.

The interior was merely a place of storage. Layers of dust covered some scattered chairs and a table sitting on an unswept floor. I noticed on the far side of the shed, a wooden door was nailed shut.

We found a way to pry the door open. I wondered how many years it had been sealed. Inside the dark closet, I shone my flashlight on some objects that I could not identify. I brought them out into the light for further identification. Were they original tools from the wire rope shop hidden away for years and years? We had no concrete answer. Somewhere in the cluttered pile of boxes, I found a broom to clear a space to place the objects. I thought cleaning Mr. Roebling's wire rope shop was an unusual way to experience history!

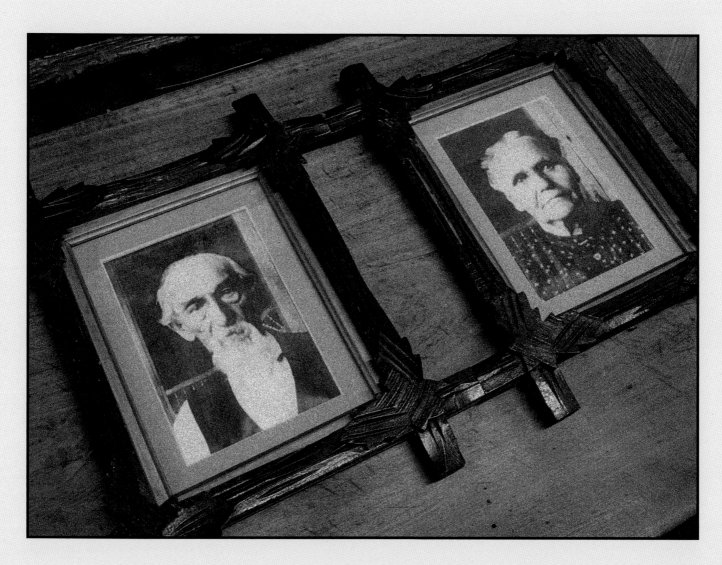

Figure 64. Portrait of the Sieberts, Saxonburg Settlers, Saxonburg Museum, Pennsylvania, 2016.

Roebling was building a life on his own terms. His creative spirit blossomed and his lucrative wire rope business brought the economic security which he had long sought. Roebling's mentor, Hegel believed "America was the land of the future" and his words began to ring true. By 1850, Roebling had completed six engineering projects, suspension structures using his own wire rope and his newly invented machines to create the product.

He wrote in his diary: "Whatever you wish to perceive you can see. You can see everything in a beautiful light and rose color, if your own mind is at ease with itself and harmoniously lived. Here is your heaven and your hell, near enough and without any search far off. Bring your own interior nature in union with the outer world, and harmony will be established."[20]

Washington Roebling worked closely with his father from a young age and his beautifully written memoir about his father, written many decades later, provides an intimate and disturbing portrait of him. Despite misgivings, Washington opted for candor: "I have debated with myself whether it is proper for me to put into writing or to allude in any way to the dark sides of my father's character. His domestic life can be summed up in a few words—domineering tyranny only varied by outbursts of uncontrollable ferocity—His wife and children stood in constant fear of him and trembled in his presence."[21]

Looking like an ancient biblical figure, John Roebling was a strong, physically towering man of six foot and three inches, with a flowing long beard. His pale grey eyes revealed an intense and icy stare. A volatile and intractable soul, John Roebling could not tolerate any disagreement. He showed no compassion for others and rarely uttered a kind word. Furthermore, he was a devout hydropathist, a believer in the curative properties of water for all ailments. In the mind of John Roebling, doctors were worse than useless, they were evil.

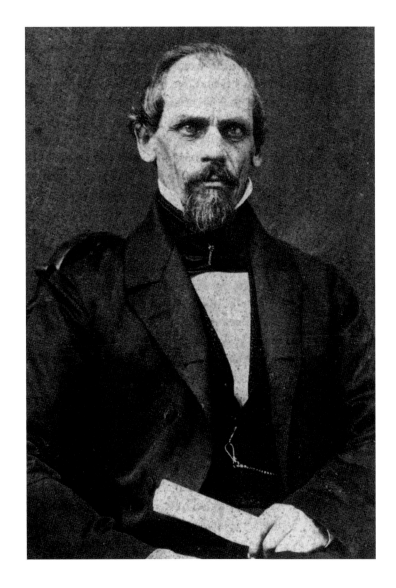

Figure 65. Portrait of John A. Roebling cover photograph from
"Washington Roebling's Father." Courtesy of ASCE Press and pd image.

As his son recalled: "The worst of it was that he insisted on treating every poor wretch that came within the sphere of his influence—he was packed and douched and steamed, plunged into cold water and hauled out by his heels, a la Achilles, sitzbathed, hip bathed, sprayed, water bagged, fomented, and revulsed and God knows what all. How I pitied my poor mother—it killed her in the end—His children would run away and would rather die than acknowledge they were sick."[22]

Washington Roebling's recollections exposed his father's complex personality. The patriarch John Roebling, albeit a man of superior intelligence, was, by contrast, a gullible person who was easily fooled by fakes and charlatans.

> I especially remember one fakir named G. Melkshane Bourne [a bankrupt picture dealer from N.Y.]— He [my father] actually allowed him to come to the house and dictate our food & drink, conduct & everything. Orders were given, no more meat, vegetables, sweets or coffee or water at table—nothing but raw graham flour & foreign fruit like dates . . . On each childs plate was put a conical heap of Graham flour 3 inches high—this was chewed dry, for 1 minute per chew by the watch and at the word of command swallowed . . . mats of dates and figs were bought, full of worms.[23]

Washington endured his father's tyranny through the nurturing of his loving mother and grandparents. He grew into a self-reliant and resourceful young man with the grit of a survivor.

At the age of eight, he was sent to a Pittsburgh boarding school, where he was mistreated, lonely and forced at times to beg for his own food. Housed in a garret filled with books and taxidermy experiments, Washington became an avid reader. In recalling these years, he reflected on his willingness to withstand intolerable conditions:

> I got along well until Satan induced the Rev. Mr. J. McLeod from Mississippi to send his son & daughter to us to board. I was moved down from the garret to room with young David McLeod. The young devil ruined my peace of mind for life. Would to God I had never seen him, he was a lunatic. No other

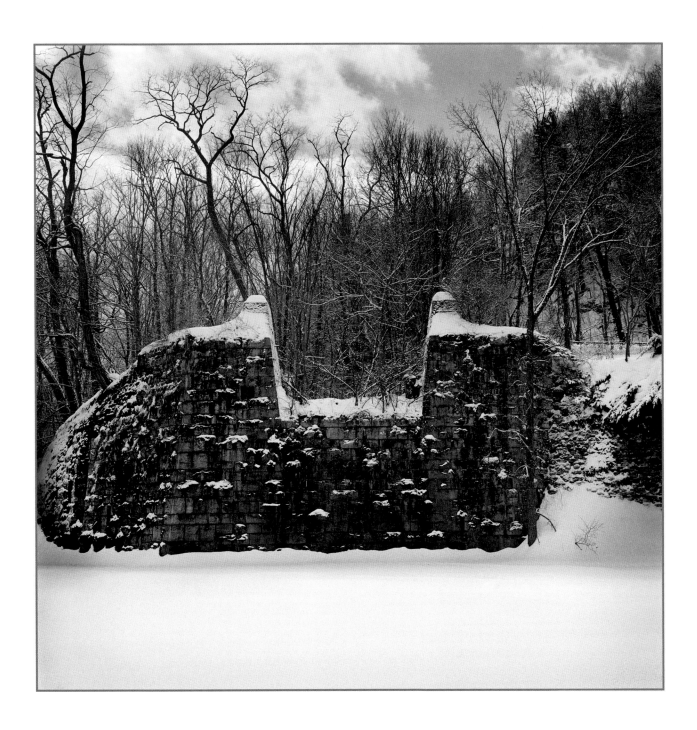

boy would have stood it—but as my spirit had been crushed by my fathers [*sic*] cowhide I was afraid to say anything, until after a few months they found it out themselves & he was moved to an asylum where he died shortly after.[24]

In 1849, a cholera outbreak forced Washington home to Saxonburg. In the same year, the entire family resettled in Trenton where the new wire rope factory was located.

Figure 66. John Roebling's aqueduct for D & H Canal, Neversink, New York, 2015.

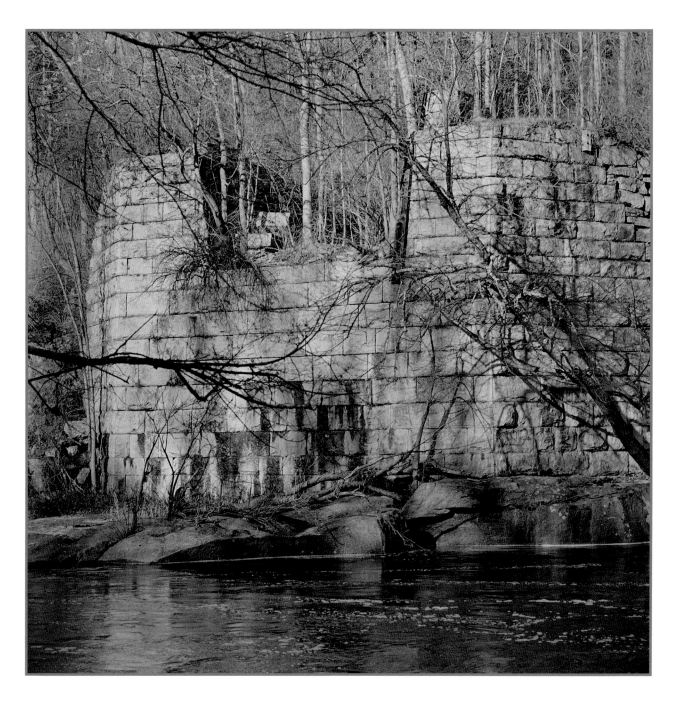

Figure 67. John Roebling's aqueduct for D & H Canal, High Falls, New York, 2017.

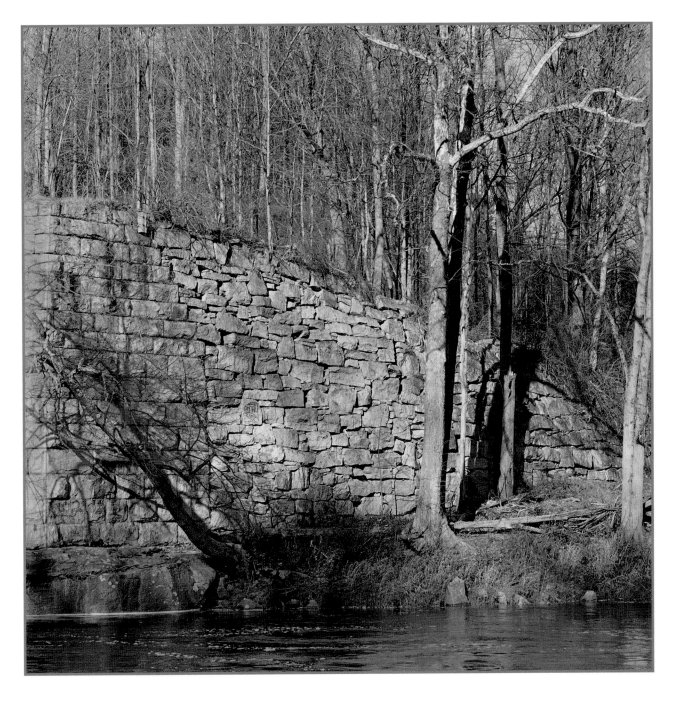

Figure 68. John Roebling's aqueduct for D & H Canal, High Falls, New York, 2017.

That December, John Roebling, while working in his new wire mill, suffered a serious injury to his right hand. "His hand was accidentally caught in one of the ascending pulleys . . . he fell to the ground, having some mangling of his hand (and fingers) and bruising of his arm."[25] The same hand that had executed exquisitely precise drawings was rendered useless.

Washington, a boy of twelve, was enlisted as his father's nurse and amanuensis. His recollection of their first journey to the Delaware and Hudson Canal Aqueduct on the Neversink River was harrowing:

> The journey was commenced in very cold weather—I went along to help him—Leaving New York we went by boat to Piermont on the Hudson, the terminus at that time for the Erie R. R. . . . Taking the train Otisville was reached in the afternoon. Then came a sleighride of three miles down the hill to the Neversink in the face of a driving Northern sleet storm—Having no overcoat or underclothes I nearly perished from cold—never shall I forget that ride. . .
>
> In May following Mr Roebling was ready for a trip to the High Falls Aqueduct. —Taking the boat we reached this place in the evening (18 miles South West of the town) and were ready for an early start next morning . . .—Here it was beautiful, fine scenery and surroundings, the aquaduct forming a conspicuous feature in the landscape—It was about finished, ready for the water in a few days.[26]

In his teenage years, Washington continued to serve as his father's assistant, enduring his harshness while acquiring invaluable technical and practical knowledge. During John's extended engineering absences from Trenton, he left Charles Swan in charge of his wire-rope factory and as caretaker to his family. Young Washington bonded with Mr. Swan.

In 1850, Roebling was contacted by the Niagara Bridge consortium. Charles Ellet, his nemesis, had resigned as Chief Engineer over political disputes. They asked if Roebling (a former bidder for the contract) would be willing to take over the work.

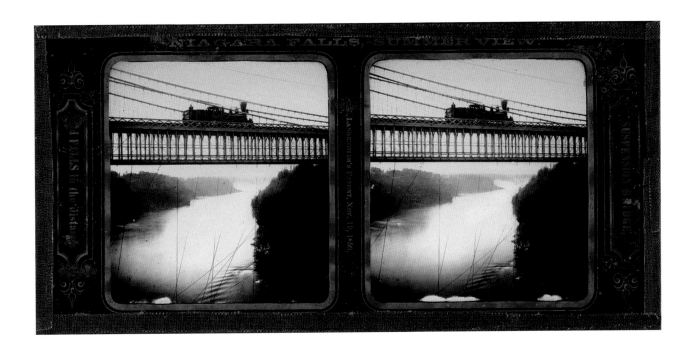

Roebling was becoming a rich man from his wire-rope business and was able to dictate his terms. He reworked Ellet's partially constructed project and confidently envisioned a solution that skeptics would call inconceivable: a double-decked suspension bridge over the gorge, with a railroad on top and roadway and pedestrian traffic underneath.

In 1853, nearly all workers at the bridge site were struck down by a cholera outbreak. Washington remembered, "Thirty died—many escaped never to return—The workshops & boarding houses were abandoned—In one shanty lay 15 corpses—No one dared to go near the place—Finally my father ordered all the buildings on the Canada side to be burnt, corpses and all."[27]

According to his son Washington, "Mr. Roebling would undoubtedly have been brought down by the disease, as he was constantly exposed to it, had it not been for the exercise of his powerful will. He determined not to have it; but once on one occasion he walked his room all the night long, fighting against symptoms that threatened to make him its victim."[28] Washington commented, "My father had a touch of it also, but cured himself . . .—pacing the floor all night & muttering

Figure 69. Langenheim Brothers stereoscope, Niagara Falls Suspension Bridge, c. 1856.

Figure 70. Worker's cabin.

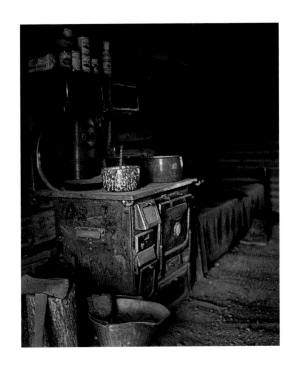

to himself—I have it not! I have it not."[29] Roebling reiterated his philosophy during this period: "Keep off fear. This is the great secret."[30]

In March 1855, the Niagara Suspension Bridge, the only bridge of its kind, opened with the first locomotive traffic, a fully loaded freight train.

> Over the years, the locomotive size, weight and traffic demands put more stress on the original bridge. Ellet's stone pillars began to erode, prompting a series of structural reinforcements. During one such period, Washington Roebling was consumed with the East River Bridge and appointed Mr. Buck, an assistant engineer on the team. "In 1890 or thereabouts, Mr Buck was commissioned to do the work. After the arch was completed he [Buck] removed the whole of the once famous Niagara Bridge suspension bridge . . . not a vestige of which remains today. Even the date stone with the Roebling name on it has disappeared, a victim to the envy which lies deep in all men's hearts."[31]

In 1854, at age seventeen, Washington was ordered to put on his clothes and shoes and "pack a little kit" in preparation to enter Rensselaer Polytechnic Institute (RPI) in Troy, New York. Although the best engineering school in the country, he considered it "the most heart breaking, soul grinding, system crushing institution in the whole world."[32]

While Washington attended RPI, John Roebling finished the Niagara Bridge and was then commissioned to build a one-thousand-foot suspension bridge over the Ohio River connecting Cincinnati, Ohio, and Covington, Kentucky. This was to be the longest suspension bridge in the world and had been the focus of Roebling's lobbying efforts for many years.

The financial crisis of 1857 caused the project to be put on hold while the mammoth towers were still under construction. Finishing school that year, Washington was obliged to return to work for his father, who was building a suspension bridge that spanned the Allegheny River in Pittsburgh. What Washington gained in professional experience he withstood in belittlement. He later remarked:

"I have long been of the opinion that a graduate should not work with his father, at least such a father as I had—When I ventured to have a different opinion on some professional problem I was called a fool—my teacher was a damned fool— but what my father had learned was right and always would be right. If I still dared to hold an opinion then came a storm of vituperation followed by a hurricane of personal abuse and attacks on my life. In his frenzied rage, the spit would fly, his arms clove the air, he jumped & swore and cursed with horribly distorted features—any man with more spunk than I had would have killed him—after the paroxysm was over it was usually found that one or two dispassionate words could have settled the whole discussion.

These uncontrollable outbursts of passion remained his leading characteristic through life, but little tempered by advancing age. Still there are times when every man must fight for himself—I do not fight enough. I am told that he inherited it all from his mother—may be it is so. . . .

In 1867 in Muhlhausen I mentioned her name to an old aunt of 80—although 35 years had elapsed since my grandmother's death, the mere sound of her name shocked my aunt so that she collapsed with fear." [33]

"I am a strong believer in inherited traits, a belief that grows stronger with age and observation. I believe that nine tenths of our characters are inherited—the other tenth is simply an educational gloss, brushed aside by any momentary provoca-tion—"[34]

After the Allegheny River Bridge opened in 1859, John and Washington returned home to Trenton. The nation was headed toward war, and shortly after Fort Sumter was attacked in April 1861, John Roebling, an avid abolitionist, demanded that his son enlist: "Washington! you have kicked your legs under my table long enough, now you clear out this minute!," his son remembered. "I got up put on my hat & walked out. Then I went over to Mr. Swan our Supt. borrowed a few dollars from him, I being penniless, then took the next train to New York."[35]

Soon thereafter, Washington enlisted in the Ninth New York State regiment and was bound for the nation's capital, an infantryman en route to the battlefield.

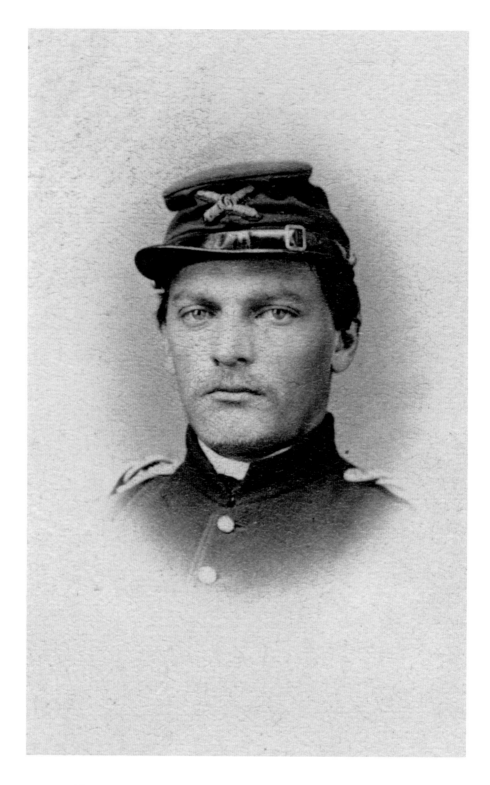

Figure 71. Portrait of Washington Roebling in Union Army uniform 1861.
Courtesy of Roebling Collection, Institute Archives and Special Collections,
Rensselaer Polytechnic Institute, Troy, New York.

The following part of Washington's story gives us a glimpse into one of the several turning points in his life. Washington Roebling's service in the military proved pivotal in both separating from his father and developing his own identity, as courageous and decisive.

During his first year, he served with his artillery unit in Maryland and Virginia and was promoted to lieutenant. He also was witness to the first encounter between the ironclads—the *Monitor* and the *Merrimac*. The sighting of the Confederate submersible, the *Merrimac*, in the Potomac, sent shudders of fear throughout Washington, DC. With great urgency, the military sought John Roebling's counsel.

Roebling may have saved his son's life. When General M. C. Meigs summoned him to the capitol to discuss barricading the Potomac River with wire rope, Roebling learned of the General's interest in building suspension bridges as a military transport tool. He suggested that his son, a Union soldier, knew more on the topic than anyone in Meigs's command.

Washington was transferred to Meigs's command in 1862 before his unit was about to enter the battle of Williamsburg, from which many would not return. Meigs ordered Washington to write a military field manual on the construction of suspension bridges and build a one-thousand-foot-long bridge across the Rappahannock at Fredericksburg, using wire rope purchased from his father.

The bridge was completed, despite a deficit of materials and labor. Roebling started two other bridges that had to be abandoned to the Confederates. In August 1862, he reported that "bridge building is hung up for a while."

Meigs assigned him as an engineering officer under McClellan's command. It is with him that Roebling experienced the battle of Antietam. "The appearance of the battlefield was horrible; the hot August sun changed a corpse into a swollen mass of putridity in a few hours—too rotten to be moved. Long trenches were dug, wide and deep, into which the bodies, thousands of them, were tumbled pell mell, carried on fence rails or yanked with ropes, unknown,

Figure 72. Gettysburg battlefield, 2016.

unnamed, unrecognized. This is the kind of glory most people get who go to war."[36]

Washington's unit regrouped to Harper's Ferry, where the piers of a destroyed bridge still remained. General McClellan sent for Lieutenant Roebling and ordered him to build a bridge across the Shenandoah. This gave Roebling the autonomy to design the structure and requisition materials and labor. The project began in October and was finished in February 1863.

This was Washington's final Civil War bridge.

After his bridge construction service, Washington was transferred to the command of General G. K. Warren, the chief topographical engineer of the Army. He became an expert in reconnoitering, drawing sketches and maps of the country to learn the terrain and determine enemy positions. He volunteered for hot air balloon service to determine the movements of the Confederate troops. Washington described this disorienting experience: "The first ascent makes one a little nervous; the rest are easy. The balloon turns around constantly, mixing up the points of compass. In a high wind, it slants so that you are almost thrown out. To use glasses and maps required dexterity and still more was needed to know what you were looking at." He also noted, "I celebrated my 26th birthday up in the balloon, May 26th, 1863."[37]

By mid-June, Washington's unit was following the movements of General Robert E. Lee. Lee's actions raised concern when the Union generals realized that they had no accurate topographical maps of southern Pennsylvania, the destination that appeared to be in Lee's path.

Lieutenant Roebling was dispatched to Philadelphia where he retrieved the government maps. He also knew that his father possessed some of the most accurate surveys of the region from his past work plotting railroad routes. He traveled on to Trenton, where he found the whole city in a panic over the advancing Confederate armies. At home, he spent a few moments with his mother, who was in very poor health. Retrieving his father's survey drawings, Lieutenant Roebling journeyed back through the countryside, at great risk of capture by the enemy, to find General Warren at the Army's Gettysburg headquarters.

Washington would soon experience the full force of General Robert E. Lee's last-ditch assault on the Union Army. His recollection is an invaluable record of the Civil War's bloodiest battle. Within three days of fighting, there were more than fifty thousand casualties. Roebling's Civil War memoir, which has yet to be published in full, gives a blow-by-blow account from the front lines. On July 2, 1863, he recalled:

> Between four and five P.M., Gen. Meade at our headquarters addressed us saying to Gen. Warren, "I hear a lot of peppering going on over yonder about Little Round Top. Suppose you ride over there and see what is going on and if there is anything serious, see to it that it is met properly." . . . Accordingly we mounted horse and rode the mile and a half or more, skirting the peach orchard and wheatfield where hard fighting was still in progress. Arriving safely we encountered the 5th corps at its base, marching towards the Wheatfield—Warren stopped for a moment to speak to them. I went on up, finding a signal officer crouching behind the rocks—as soon as I showed my head above the stones, bullets began to whistle about my ears. I could see confederates in the woods in front—I rushed back to Warren and we both came up. In these few minutes the enemy had approached in force.
>
> Hood's Texans in solid column were marching forward between the two Round Tops. Their advance had already crossed the Taneytown Pike and penetrated behind our lines.
>
> Not a moment was to be lost. The summit of Little Round Top must be held at all hazards. . . .
>
> I was busy assisting Hazlitt's battery in getting up. The way was so steep that the horses could not pull the guns. We had to help pushing them up by hand. The moment a section got up it opened fire with good moral effect. Hazlitt was killed right away. Weed's brigade was all engaged now, but Weed himself was killed soon. Vincent died later- Mostly victims of sharpshooters who picked off everyone exposing himself on the summit.
>
> Warren had his throat grazed by a ball. Col. Chamberlain of the 20th. Maine gave the first decisive check to the enemy, driving them back through the ravine between the two Round Tops, into what was veritably a devil's den.[38]

On the morning of the following day, the Union troops were dangerously scattered. Facing an imminent attack from General Lee, Washington was sent out to survey the Union lines.

Figure 73. Light over Little Round Top,
Gettysburg battlefield, Pennsylvania, 2016.

It was essential that this "mix-up" be straightened out before Lee commenced his attack.

> Thus it was that Butterfield, Meade's chief of staff, sent for me to produce order out of chaos. There was only one way to do it—namely to ride from the extreme left of the line, from Big Round Top along the entire front, passing Cemetery Hill and winding up with Culp's Hill, nearly three miles, and note down every regiment. . . . After three hours I returned safely to headquarters, making my voluminous report. Orders were at once sent out assigning everyone to their proper place. This was accomplished before Picket's [*sic*] great charge.[39]

No sooner had Washington delivered his report when Lee began his attack, a tremendous cannon volley seemingly aimed at the headquarters of General Meade.

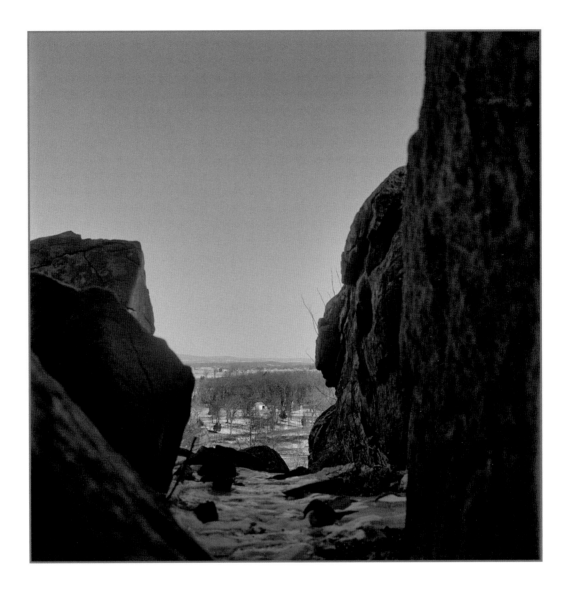

I had scarce returned to the absurd little two-room log house, misnamed headquarters, when two solitary cannon-shots were heard. Instantaneously a hurricane of cannonshot fell upon, around and about us, accompanied by an appalling roar as of a thousand thunders. During that morning, Gen. Lee had placed in position one hundred and thirty-eight (138) cannon; they were discharged as one volley on hearing the signal of the two cannon, and each one made that little house its target. The rain of destruction kept up for nearly an hour. We all felt that the great cannonade was merely the prelude to an infantry attack, with which Lee hoped to overwhelm our lines. He had pointed out to his gunners a small clump of trees, located several hundred feet in front of the little house, which was to be their aim. In their excitement smoke and confusion they all overshot their mark, thus making this spot the real focus of countless

Figure 74. View from Little Round Top, Gettysburg battlefield, Pennsylvania, 2016.

shot and shell. Nearly forty-five years have elapsed since that day. The impressions left by that event are as vivid now as then. I fail to find words which would portray the absolute paralyzing horror of the situation.

It was of no use to try and run away; all you could do was to stand still and commend your soul to God. Our little house was repeatedly hit, one ball through the garret, another carries away the steps, a third the posts of the porch. A fragment of shell flying in through the door knocked down the table at which Col. Paine and myself were looking at some maps; we promptly ceased that occupation.[40]

Washington escaped headquarters and rode into battle:

Outside a string of horses were tied to the picket fence, a dozen were quickly killed. Another shot demolished the rest of the fence, setting my horse free. I had to run out to catch him. My horse was one of three unhurt. Meade's boots were grazed by a ball. The lay of the ground was such that the flying missiles would just skim the surface for a long distance, permitting nothing to escape. A perfect rain of shell fragments came down from above. As a rule the enemy's guns overshot their mark, hence the line of our troops lying flat on the ground behind a slight rise were reasonably protected. Many were killed a mile beyond us, as far back as Culp's Hill, and farther. At last it became a question of moments when we might all be killed, and those that were left retired to one side or the other, vainly seeking safer places. I rode up to Woodruff's and Cushing's batteries, where more ghastly sights met my gaze. They lost most of their horses and men, their guns were dismounted, but they held their ground; every moment the sickening thud of a ball passing through a horse was heard; neither was it an infrequent sight to see a poor beast fly to pieces from a shell exploding inside of it. . . . Under all this terrific fire Gen. Meade never lost his head nor did his judgment waiver. Feeling sure that Lee would attack in the centre he made due provision by drawing troops from all available sources and massing them at the probable point of attack.[41]

After the cannonade, the infantry advanced into overwhelming fire by Union troops: "The field they had advanced on was strewn with the dead, the wounded, and

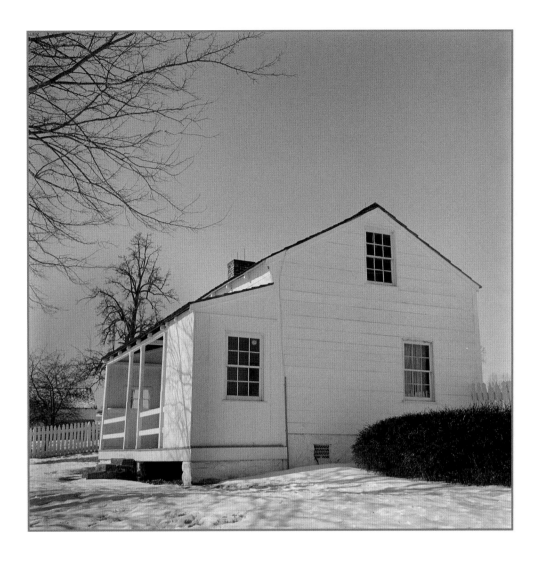

those who had thrown themselves on to the ground to escape annihilation. No troops could have withstood our terrible fire. . . . Anxiety gave way to exultation on our part, cheers were heard on all sides as the prisoners were gathered in by the thousand."[42]

Washington attributed the Union victory not to the battlefield but to the strategic weakness of the Confederate position: "We had a feeling that this was the last effort on part of Lee, not because there was not plenty of fight left in his men, but because they had nothing to eat. The country had been ransacked of all available food supply, and as he had no railroad leading south to his own magazines, there was no alternative left but to starve or retreat. . . . Thus ended the third day."[43]

Figure 75. General Meade's Headquarters, Gettysburg battlefield, Pennsylvania, 2016.

Visiting Gettysburg National Monument in winter is truly memorable. Hordes of people traveling in tour buses or walking in large groups with professional guides are nowhere to be found. Instead, the fields where the violent battles of the Civil War took place are enveloped in emptiness and silence.

On the coldest day in winter, where the temperature dipped below zero, I climbed to the summit of the mountain ridge, known in history as Little Round Top. From this location, the force of the bitter cold wind nearly knocked me down. From this hilltop position, I could see the crisp early morning light reveal the outlines of the vast fields and rocky terrain below.

In 1863, in the heat of summer, fifty-three thousand soldiers would be injured or killed during the battle of Gettysburg, the fiercest battle of the Civil War. In my mind's eye, men armed with rifles hid behind massive boulders, and in a life-and-death struggle strained to see, hear, or sense a surprise attack from the enemy lurking below.

As the trees swayed and snapped in the force of the wind, a shrill high-pitched whistle enveloped the landscape. The sound of the wind seemed to evoke a cacophony of terrifying and melancholy voices eerily reminiscent of the dead crying out from the valley below.

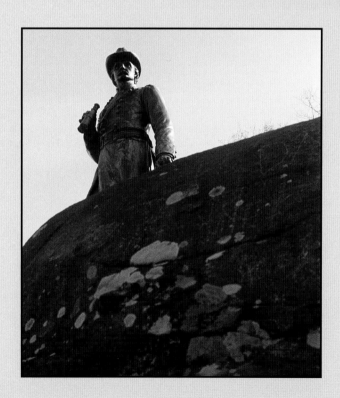

Figure 76. General Warren, on the Gettysburg battlefield, Pennsylvania, 2016.

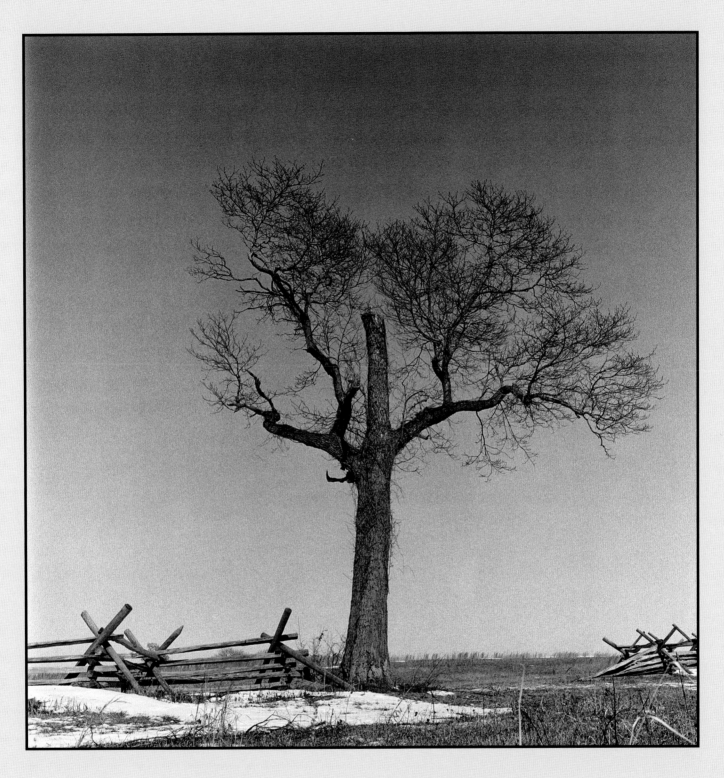

Figure 77. Distressed tree on the Gettysburg battlefield, Pennsylvania, 2016.

Over six months later, Washington's performance in the military earned him the rank of breveted colonel. He organized a military ball honoring his commanding officer General Gouverneur Warren. At the event, Washington met his future bride, Emily Warren, the general's twenty-one-year-old sister.

Emily Warren was raised in a large family of twelve children. After the death of their father, it was Gouverneur (fourteen years her senior), who shepherded her to an education at Georgetown Visitation Convent. Like her brother, Emily gravitated to science and mathematics and graduated with honors. This accomplishment was a rare occurrence for a girl from Cold Spring, New York.

In a letter to his sister Elvira, Washington described his first encounter with Emily in military terms: "It was the first time I ever saw her and am very much of the opinion that she has captured your brother Washy's heart at last. It was a real attack in force, it came without any warning or any previous realization on my part of such an occurrence taking place, and it was therefore all the more successful and I assure you that it gives me the greatest pleasure to say that I have succumbed." [44] During this period, flurries of letters went back and forth between Washington and Emily. "Yesterday Brady took the picture of G.K. and staff. Luckily I was absent on business and I am spared the pain of seeing myself perpetuated in my present appearance."[45]

In his letters, Washington revealed intimate and foreboding dreams. "I dreamt three nights in succession of a veiled lady who the spirit of my dreams told me would be my helpmate during life. The face I did not see, but months passed away before the impression wore off."[46]

In less than a month, Washington wrote to his father of his intention to marry "Emmie," and to his surprise, John Roebling wrote him a respectful reply:

My Dear Washington,

Your communication of the 25th came to hand last night, and I hasten to reply. . . . I take it for granted, that love is the motive, which actuates you, because a matrimonial union without love is no better than suicide.

I also take it for granted, that the lady of your choice is deserving of your attachment. These two points being settled,

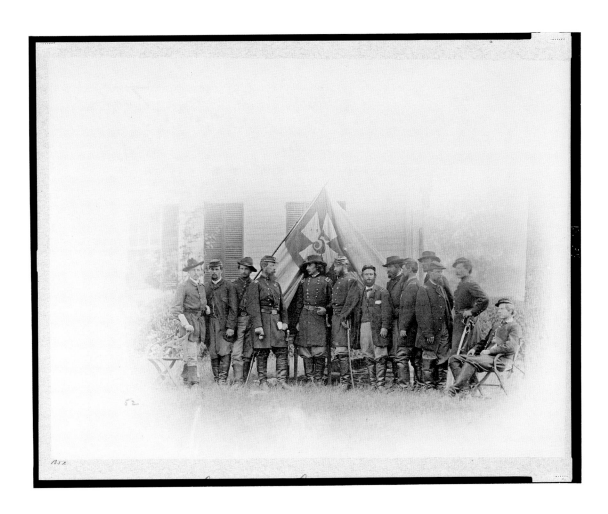

Figure 78. Portrait of General Warren and his staff (without Washington Roebling) photographed by Mathew Brady. Courtesy of Library of Congress.

(right) Figure 79. Close-up of the portrait of General Warren and his staff.

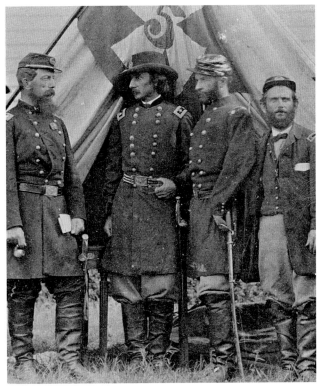

there stands nothing more in your way except the rebellion and the chances of war.[47]

That fall, Washington's mother, Johanna Roebling, fell ill and died. Having mistreated his wife in life, John grew repentant. In the family Bible, he wrote: "Of those angels in human form, who are blessing the Earth by their unselfish love and devotion, this dear departed wife was one. . . . My only regret is that such pure unselfishness was not sufficiently appreciated by myself. . . . In a higher sphere of life I hope to meet you again my Dear Johanna! I also hope that my own love and devotion will then be more deserving of yours."[48]

Washington recollected his mother's passing without sentiment: "The poor woman was glad to die, even at 48. She had had a hard life—worn out with hard incessant work, many children—her nerves racked by the never ending, everlasting, continuous senseless useless scolding on part of her husband, she gave up in despair.- he would allow her no doctor—she literally died from being stuck in cold water all the time—at the last moment Dr. Coleman was smuggled in so as to be able to give a death certificate."[49]

During the war, the demand to move soldiers and supplies across the Ohio River rekindled in the citizenry the desire to complete their bridge. In 1863, John Roebling was called back to Cincinnati to resume work on the two partially completed towers rising from the opposing riverbanks.

When Washington was discharged from the Army in January 1865, his first act was to marry his beloved Emily. But two months later he found himself on the Ohio River, joining his father where the two huge towers were nearly finished and the bridge ready for cabling. Upon his arrival on March 10, 1865, he wrote home to Charles Swan with his first impressions of the rising structure: "The size and magnitude of this work far surpasses any expectations, I had formed of it previously. . . . the towers are so high a person's neck aches looking up at them. It will take me a week to get used to the dimensions of everything around here."[50]

Washington Roebling honed his expertise, the spinning of cables, while working on the Cincinnati bridge. His notebooks and drawings reveal in meticulous detail, the knowledge he acquired and risks taken while experiencing on the

Figure 80. Tower thrust, 2016.

job training. "The maintenance of a long narrow footbridge in the winters gales was a matter of difficulty. It tore apart several times—to fix it was my job, always at the risk of my life. On one occasion I could only return by walking on the main cable back to the top of the tower—Before reaching it my strength gave out—below me was sure death—How I managed to cover the last 100 feet is still a hideous nightmare to me-"[51]

John turned over the reins of the project to his son. Washington, with Emily by his side, would spend the next two years completing the bridge. John would return periodically, but his attention was focused on his next great suspension bridge.

Figure 81. Cincinnati bridge (John A. Roebling Bridge), 2016.

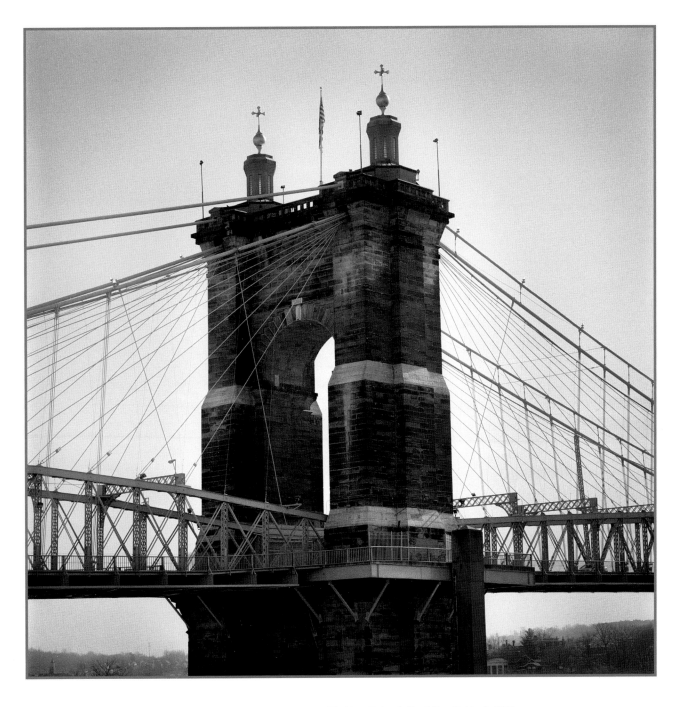

Figure 82. Tower of the Cincinnati bridge (John A. Roebling Bridge), 2016.

Upon its completion in 1867, the Cincinnati Covington Bridge spanning the Ohio River (known today as the John A. Roebling Bridge) was once the largest suspension bridge in the world. To the contemporary eye it is a veritable "Mini Me," a prototype for the Brooklyn Bridge.

John Roebling's designs for his aqueducts and bridges were characterized by their durability. In 1937, the Ohio River experienced catastrophic flooding, the worst in its history. During this great flood the river crested to an apocalyptic 79.99 feet. The Roebling bridge was the only river crossing in operation between Steubenville, Ohio, and Cairo, Illinois, some eight hundred miles further west.

In 2015, when the winter shadows were long and crisp, it was an opportune time to photograph this unique bridge and walk across the span to Kentucky. Descending the stairs of the embankment in Covington, my attention was directed toward a series of murals painted on the flood wall bordering the river. The long barrier was transformed into a marvelous work of art depicting the history of the region.

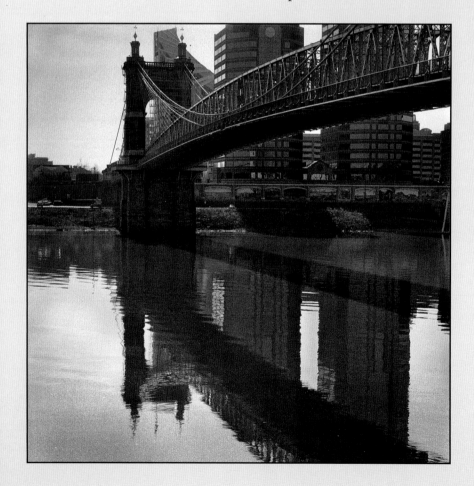

Figure 83. Cincinnati bridge (John A. Roebling Bridge) looking toward Kentucky and showing flood wall, 2016.

I came across the panel celebrating the Cincinnati Covington Bridge, which opened on New Year's Day 1867. As the artist interpreted the event, John Roebling looked physically uncomfortable standing next to Amos Shinkle, who financed the project. Behind them, the new bridge was glistening in the sun as the steamboats churned up and down the Ohio River.

Figure 84. Flood wall, Covington, Kentucky, 2016.

Amos Shinkle (born in Kentucky in 1818) represented the quintessential rags-to-riches American success story. His life was mirrored against the growing industrialization of the Midwest. Shinkle mastered the art of investing in many business ventures including the transporting of coal and buying and selling of real estate. While Shinkle was praised and beloved in his home state of Kentucky for his philanthropy, to others like John Roebling, he represented a new breed of man: the capitalist hell bent on stepping over anything and everyone to make money.

Washington wrote of Shinkle: "He was a thorn in my father's side; why he actually rented the (bridge) towers to be plastered with advertisements from top to bottom." Amos could make money where all others failed—he could buy cheap and sell dear, and was familiarly known as a 'skinner,'" Washington wrote. "When the bridge was opened it was a Sunday—At 10 A.M. the crowd broke down the barriers—Amos was sent for from church (rushing out during the long prayer) seizing a big basket he mounted a barrel and collected pennies from 11 A.M. until 11 P.M. Not a penny got away from him, and the basket held $700 worth."

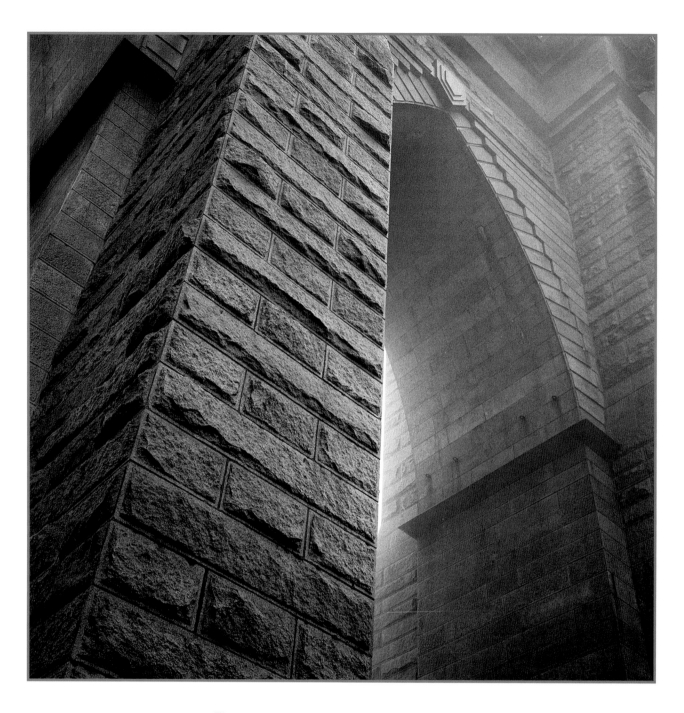

Figure 85. The New York tower, Roebling's "Folly," 2008.

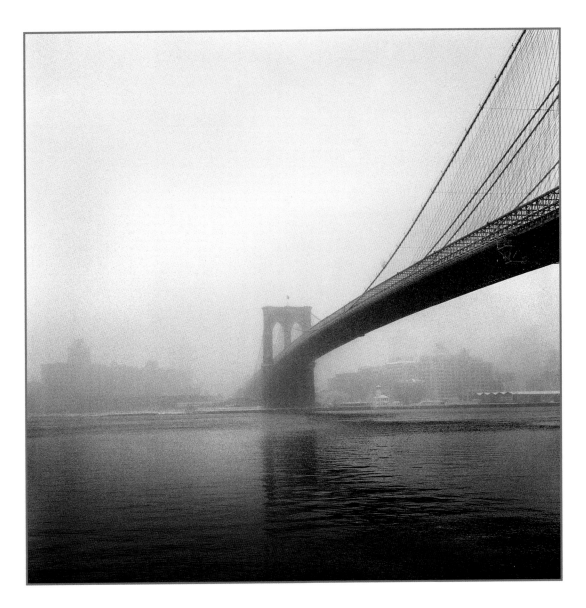

Figure 86. Brooklyn Bridge, 1998.

The particularly frigid winter of 1867, which iced-in dozens of ferryboats that traveled across the East River hundreds of times a day, proved to be a final catalyst to the formation of the New York Bridge Company, which aimed to finance and direct the world's largest suspension bridge, between Brooklyn and New York, surpassing what was just accomplished in Cincinnati. John Roebling—whose principal rival, Charles Ellet, had died during the Civil War—lobbied fiercely and won the commission that would be his masterpiece.

In Roebling's plan, the span would exceed 3,500 feet. The Gothic towers would reach upwards of 270 feet and four immense steel cables would suspend the roadway 100 feet above the river, high enough to allow the tallest clipper ship to pass underneath. The plan would call for strength, a perfect

balance of competing forces between the steel cables and stone towers. Accommodating heavy loads including vehicles and trains was only part of Roebling's future plan. Roebling envisioned a walkway above the flow of traffic. The towers would serve as great gateways. As one passed through, the light reflecting from the arches would enthrall and inspire. The wide promenade would soar high above the river, where breathing fresh air and experiencing open space would give the average citizen a sense of exhilaration and freedom.

In his report to the stockholders, Roebling declared: "The contemplated work, when constructed in accordance with my designs, will not only be the greatest bridge in existence but it will be the great engineering work of this continent, and of the age. Its most conspicuous feature, the great towers will serve as landmarks to the adjoining cities and they shall be entitled to be ranked as national monuments as a great work of art and as a successful specimen of advanced bridge engineering."[52]

Following his completion of work on the Ohio River Bridge, Washington Roebling left for Europe in July 1867 to research the emerging science of underwater foundations, essential in constructing the two towers of the East River Bridge. Emily, although four months pregnant, accompanied her husband on the arduous trip.

The couple toured bridges, visited iron and steelworks in England, France, and Germany and consulted with other bridge builders. Washington proved to be fastidious at memorizing, visualizing, and recording useful information in his own pocket-sized notebooks. He recorded notes, drawings, and letters with a discerning attention for detail.

While touring the Krups Ironworks in Essen, Germany, Emily lost her footing and tumbled down a metal staircase. In Mühlhausen, the birthplace of her celebrated father-in-law, Emily gave birth to a son. The baby was baptized John Roebling II in the Divi Blasius Church, where many years ago, the patriarch of the family was blessed in the same stone baptismal.[53] Because of the accident, she would have no other children.

When the couple returned to New York in the spring of 1868, plans for the bridge were well underway.

Figure 87. Baptismal in the Divi Blasius Church, Mühlhausen, 2014.

Figure 88. Roebling's first calculations for the East River bridge, 1867. Courtesy of Special Collections and University Archives, Rutgers University Libraries.

0'

800'

d
c
l
a

75'

150'

150'

250'

400'

473'

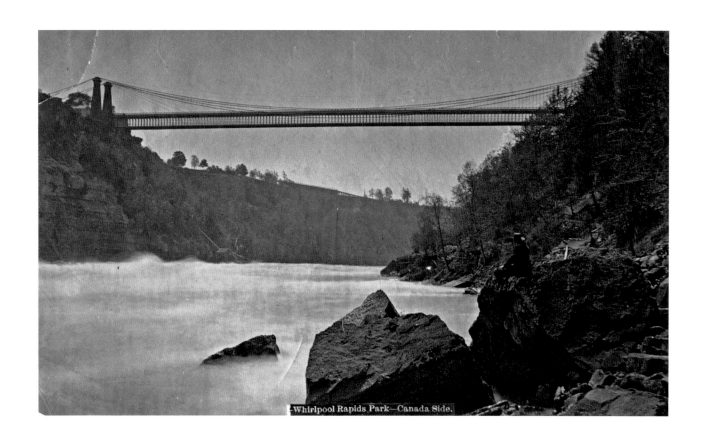

Whirlpool Rapids Park—Canada Side.

Figure 89. John Roebling's railway
suspension bridge, Niagara Falls.
Courtesy of Buffalo History Museum,
Buffalo, New York.

In April of 1869, to convince skeptical bridge officials, John
Roebling organized a private train tour of four of his most
noteworthy bridges. The party first travelled to Pittsburgh, to
see his first suspension bridge, the Smithfield Street Bridge
and his newest, the Allegheny River bridge. They traveled from
Pittsburg to Cincinnati, to view his great bridge over the Ohio
River, most closely resembling the proposed East River Bridge.
Then on to Niagara Falls, to view a less imposing bridge,
but one that spanned a magnificent gorge and had been
supporting both roadway and railroad travel for nearly fifteen
years— a true testament to Roebling's engineering.[54]

In the summer of 1869, as Washington was assisting his father with surveying the location for the Brooklyn tower, a freak accident occurred at the future construction site. In a report to the Bridge Company, Washington explained what had happened: "It was while engaged in locating the position of the Brooklyn Tower that Mr. John A. Roebling met a lamentable accident—the crushing of his right foot by the shock of a ferry boat against the fender rack of spring piles on which he was standing."[55]

Rushed to a nearby doctor's office, his crushed toes were amputated. Roebling, the stoic, would have no anesthetic administered, although he was in extreme pain. After the emergency amputation of his toes, the patriarch was then taken to Washington's house on Hicks Street, shunning further doctors' care.

Mr. Roebling insisted on treating the wound himself, designing a tin contraption which would allow for water to pour constantly over his wound. Within a few days the wound became contaminated with the deadly bacterial disease of tetanus (or "lockjaw"), a progressive disease characterized by chronic spasms of the nervous system leading to violent seizures and a tightening of the muscles around the mouth and jaws, denying the patient the ability to eat or drink. "Daily and hourly, I was the miserable witness of the most horrible titanic convulsions, when the body is drawn into a half circle, the back of the head meeting the heels, with a face drawn into hideous distortions—Hardened as I was by scenes of carnage on many a bloody battlefield, these horrors often overcame me—When he finally died one morning at sunrise I was nearly dead myself from exhaustion."[56]

The trustees of the Bridge Company gathered in Trenton for John Roebling's funeral. They had little choice but to appoint his thirty-two-year-old son as chief engineer.

Washington Roebling took charge without any reservation, although he alone knew how much his father had left unresolved.[57]

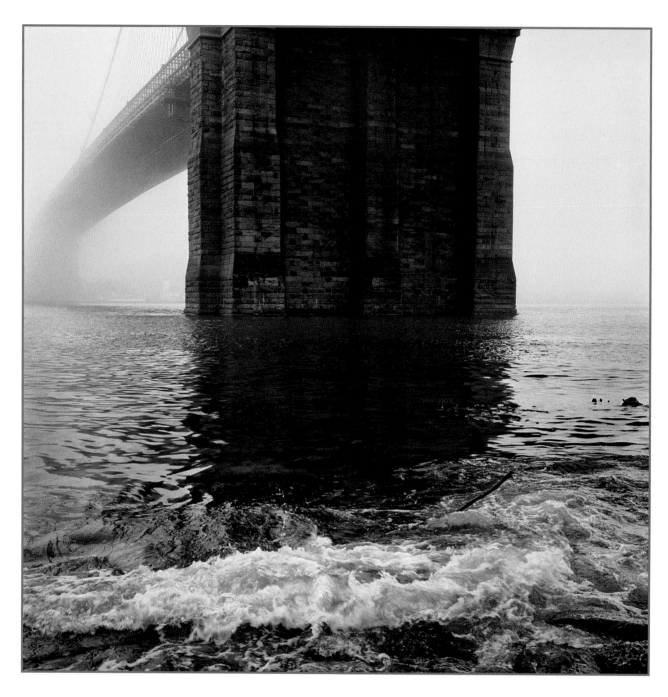

Figure 90. The eternal wave, 1998.

Among the many challenges Washington faced in the construction of the Brooklyn Bridge was the sinking of two giant foundations, upon which John Roebling's magnificent Gothic towers would rest. The towers required the construction of underwater pneumatic *caissons*—gigantic, upside-down, watertight, wooden boxes filled with compressed air. Although room-sized caissons had been built in Europe, the caissons for the Brooklyn Bridge needed to be significantly larger, virtually the size of a city block. Nothing of this size and scale had ever been built.

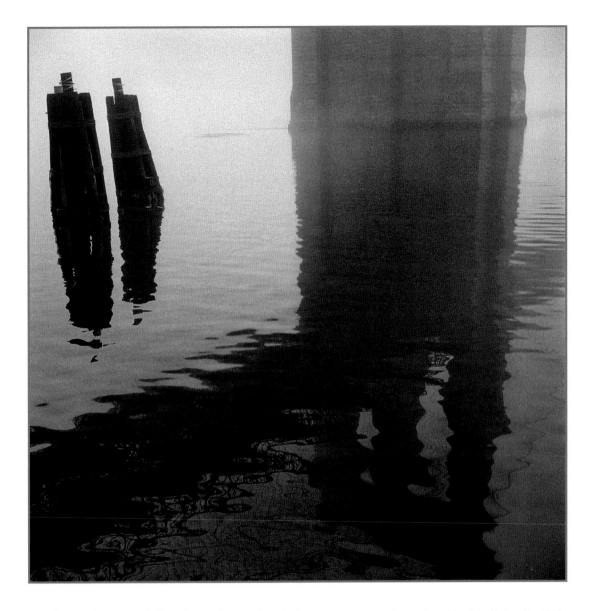

Figure 91. Hidden for all eternity, 2009.

The men who volunteered for the grim task of the excavation to bedrock were immigrants of Irish, German, and Italian descent. Round the clock, shifts of laborers working in unbearable heat toiled—first with picks and shovels and later with gunpowder charges—to remove putrid-smelling river debris and large boulders which were hauled to the surface through Washington's ingeniously designed water shafts. In theory, the caissons would slowly descend, forced downward to bedrock by the increasing weight of the stone towers being constructed overhead.

Once the digging ended, the caissons would be filled with concrete, invisible and hidden for all eternity. Upon completion, each caisson would balance approximately ninety-three thousand tons of masonry.

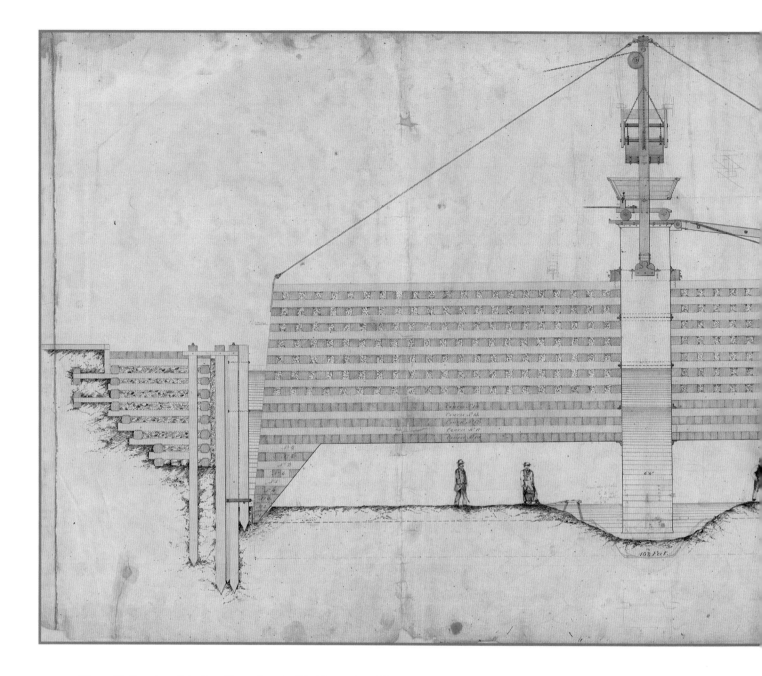

Figure 92. Drawing of the Brooklyn caisson by Washington Roebling, 1869. Courtesy of Municipal Archives, New York.

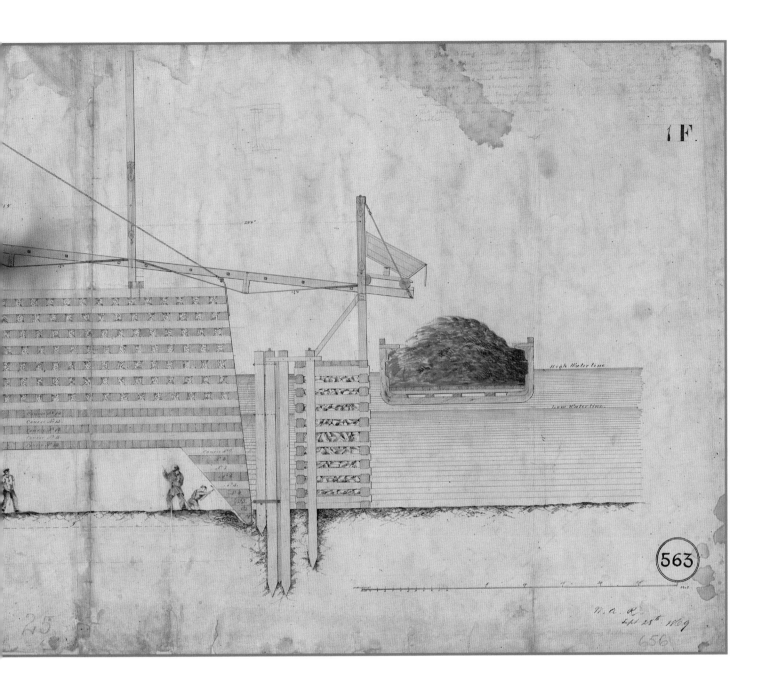

563

Figure 93. Detail drawing showing timbers.

On December 2, 1870, six months into the excavation, a fire broke out in the thick timber-roofed ceiling of the Brooklyn caisson. It started when a worker's candle ignited a patch of accidentally exposed oakum, a highly flammable wood sealant. During the fire, which was visible only to those working down in the caisson, Roebling was summoned and remained in its depths all night. With herculean effort, he fought the inferno and calmed the workers' sense of panic. By daybreak, when it seemed the fire was out, Roebling emerged into open air, feeling excruciating pain in his joints. He was brought home and rubbed down with whiskey and salt to revive his circulation.

Within hours, a messenger brought news that fire was again detected. With a soldier's sense of purpose, Roebling returned to the Brooklyn tower and descended again into the caisson to confront the underground fire. This time, Washington made the critical decision to flood the caisson, releasing its air pressure and risking the collapse of the first layer of the stone tower overhead.

Following his order, it would take nearly all day—requiring the use of every available fire boat, tug boat, and fire engine, even those ferried from Manhattan—to flood the caisson. The caisson remained flooded for two days. When the air pumps were reengaged, the caisson had kept all its air-tight qualities.

Washington began to engineer the repair of the fire damage, but his health had been compromised. This was his first bout with "caisson's disease," a mysterious malady afflicting many of the men who toiled far beneath the surface of the water. Today, this condition is called "the bends" which, we now know, is induced by moving too quickly from compressed to normal atmospheric pressure. Victims suffer from joint and abdominal pain, headaches, nausea, vomiting, dizziness, vertigo, convulsions, partial paralysis, and sometimes death. Workers would say that Roebling was never quite the same.

Despite his weakened constitution, Roebling continued to work in the caisson to supervise repairs and the construction of pillar supports, which required lowering into place 250,000 bricks (to help compensate for the fire-damaged rafters). Under Roebling's direction, the Brooklyn caisson was completed in March 1871. Shortly thereafter, work on the New York tower began.

Although Roebling introduced many improvements, based on the experience of building the first caisson, the New York tower posed a new and graver problem. Bedrock below the river bed was sixty feet deeper than the Brooklyn side. On April 22, 1872, at a depth of seventy-one feet, a worker died after emerging from the caisson. This was followed by another death on April 30. On May 2, another laborer was stricken and a week later, at a depth of seventy-six feet, a fourth worker was stricken and died the next morning.

Washington used his extensive knowledge of geology to analyze the core samples taken from beneath the caisson and concluded that a layer of prehistoric fossils, encased in once boiling sand, had not shifted for millions of years. Faced with another year of digging to reach bedrock and an unknown number of deaths, he executed the most important decision of his life, risking the successful outcome of the

Figure 94. Detail drawing showing
layers of soil in riverbed.

bridge, his professional reputation, and the economic invest-
ment of America's fastest-growing city. Washington Roebling
ordered a halt to the digging. The New York caisson would
rest on sand.

It would take two months to complete filling the
New York Caisson with concrete. During this period, on a
day when Washington had made several descents into the
caisson to supervise the concrete pour, he was stricken by his
second major attack of decompression illness. He collapsed
at the site and was rushed home. Morphine was administered
in an attempt to ease the intense pain. Emily questioned if
her husband would survive the night. Instead, he hovered for
days at death's door, lying in the same Hick's Street house
where he had watched his father die three years before.

It will never be known if Washington drew upon
his father's "mind-over-matter" denial of ailments, but
Washington rallied and soon was back at his work. Despite
his heroic recovery, Washington's physical and emotional
condition degenerated through the summer months. By July,
the New York caisson was completed and filled with concrete.

Taking time off, Washington and Emily sought a cure for his degenerative condition in Saratoga, New York, with no positive results.

By 1872, the Bridge Company was running out of money. A committee, formed to investigate fraud and embezzlement by the president, the notorious "Boss Tweed," presented its findings. Tweed was found resoundingly guilty, having stolen millions of dollars from the city's coffers. Against this backdrop of scandal, Washington and Emily experienced a turning point in the life they shared. As the winter months brought ice floes paralyzing the East River, Colonel Roebling became an invalid. The chief engineer would experience chronic pain and numbness in his arms and legs. He no longer had the stamina to walk. His stomach was churning with constant nausea. He grew weary, despondent, withdrawn, and irritable.

Emily confided her husband's medical condition to Henry C. Murphy, chairman of the board of the Bridge Company. She expressed her husband's commitment to the bridge and their desire that he continue as chief engineer. Concluding that this arrangement would be short-lived, Emily received Murphy's assurance that her husband could continue as long as nothing went wrong. But months stretched into eleven years![58]

Construction on the bridge had been halted during the frigid winter. At home on Hicks Street, Washington was haunted by images of a hellish end to his life. At fever pitch, he continued planning his father's bridge unabated, drafting in minute detail, instructions, and specifications for the work still to be done. Fortunately, the result of these months of frantic design meant that the plans were months and years ahead of the construction schedule. In his bedroom, surrounded by vials of medicine and elixirs, this resolute man with failing eyesight sketched out diagrams, notes, and illustrations in freehand. Doctors would privately tell Emily the chance of recovery was slim. The only hope for his survival, on the doctors' recommendation, was to remove him from the bridge.

In April 1873, a leave of absence was requested and granted. The Roeblings then traveled to Wiesbaden, Germany, seeking a water cure, which failed to help. When describing

his own condition in private correspondence, Roebling himself does not seem to have used the words "bends" or "caisson sickness." He spoke only of his nervous disorder and of his crippled condition. Farrington (his assistant) would later describe him as "a confirmed invalid . . . owing to exposure, overwork and anxiety."[59]

In early 1874, the couple returned, to Trenton, sixty miles from the bridge. With a memory for retaining detailed information, Washington continued work on the bridge by issuing directives from his sickbed that lead to the completion of the towers, including directions as to the placement of saddle plates and machinery for cable making. Emily was assigned with the task of taking down dictation, which was slow and arduous.

By 1876, the towers and saddle plates were successfully completed. Cable spinning would begin immediately on the span over the East River. Washington's health had hardly improved, but his incalculable experience gained in Cincinnati was in this area of expertise. Washington was eager to return.

The couple and their young son returned to New York, and eventually moved to a new house on Columbia Heights. Roebling's parlor had a breathtaking view of the two towers now soaring above the river, appearing as giant portals to a rapidly growing city. Although his sight was impaired, with a small telescope Roebling could watch, in short durations, progress on the bridge.

The chief engineer continued to dictate daily instructions, which Emily conveyed to the foreman at the job site. Her role in managing Washington's affairs widened to include attending social events and meetings in his place. While at home, she also received employees, contractors, tradespeople, and politicians and dealt with a lawsuit initiated by engineer James Eads (who was Roebling's competitor in the development of underwater caissons). She continued her roles as amanuensis, private nurse to her husband, and mother to her young son.

On a warm day in June, when cable spinning was underway on the anchorage, men perched on the top of the massive granite blocks were violently thrown from their work. With a terrible noise a cable broke loose with such force that it killed two men and severely injured several others.

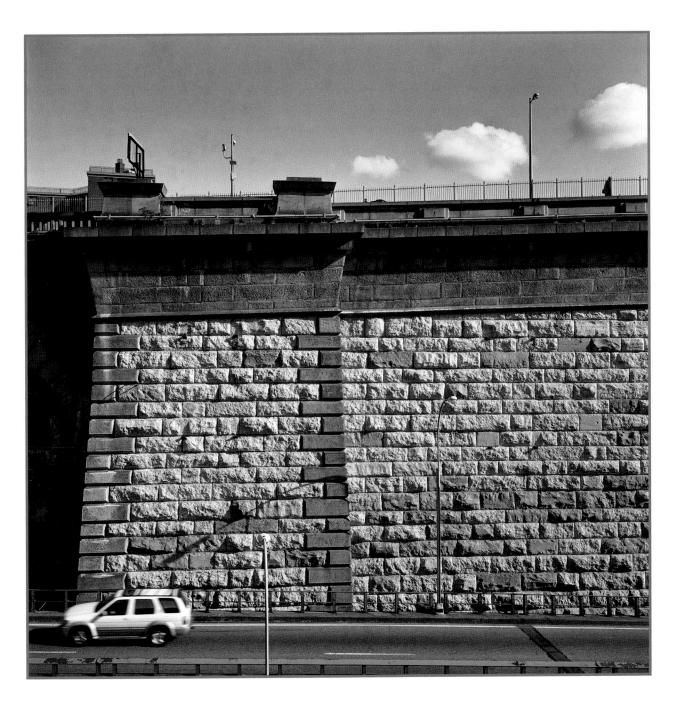

Figure 95. New York anchorage (view from my window), 1990.

This unleashed a new debacle. Upon examination, it was found that the broken wire was inferior and brittle. Tons of faulty wire had deceptively avoided inspection and found its way into the cables of the bridge, threatening its safety. This event ignited feuds, mistrust, and accusations of kickbacks. To avoid a political scandal, the wire supplier, J. Lloyd Haigh, who had committed this wire fraud, was not fired. It was kept quiet. Instead, he was forced (by Colonel Roebling's orders), to supply higher-quality wire from reputable sources at his own expense. Haigh would eventually end up in Sing Sing prison for passing bad checks.

However, in true Roebling fashion, the bridge had been designed to be six times stronger than necessary. Since it was impossible to remove the bad wire, Washington concluded that the bridge could be completed with quality wire without compromising its safety—each cable was strung with 150 more wires than originally planned.

With each new decision, the stress attached to the work intensified. Washington grew increasingly isolated and nervous, discouraging all visitors except for Emily and on rare occasions, a handful of assistants. It is difficult to know how much his reclusive behavior was due to his physical condition or the anxiety and depression from which he may have suffered.

Washington became an object of mystery to the public. Questions were swirling: "Why was Colonel Washington Roebling in hiding and who was really in charge?" Despite their desire for privacy, the couple exposed themselves to questions about Washington's competence and whether Emily was the "real engineer." These hushed rumors continued for years, becoming fodder for the daily newspapers. The controversy culminated in 1882, when the board narrowly defeated a vote to cast him out. Lobbying efforts by Emily had influenced just a few votes, enough to keep her husband in charge of the project.

Washington Roebling did not hesitate to express his rage at the enemies he had on the board of trustees. "Most of their meetings in thirteen long weary years of the work had been spent in quarreling amongst themselves over petty trifles or in insulting the engineers . . . I was in the way of any schemes for robbery. . . . It took Cheops twenty years to

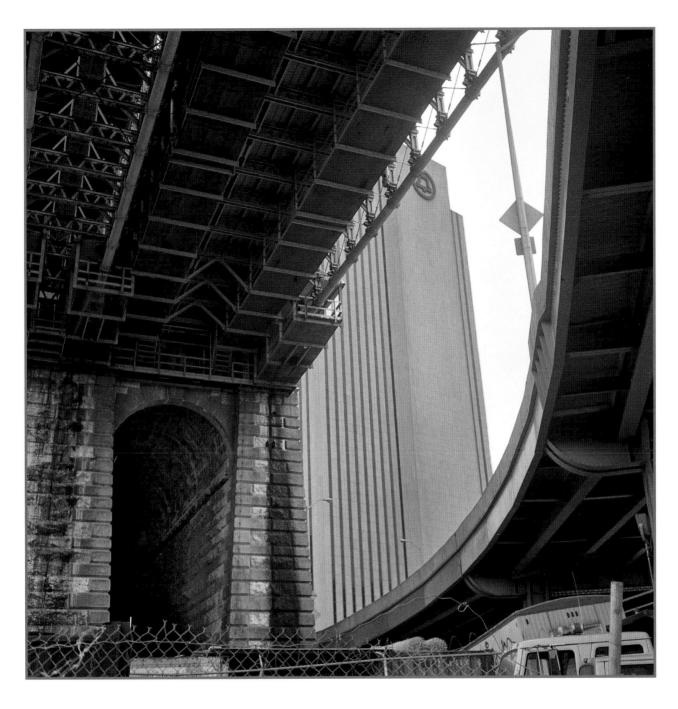

Figure 96. New York anchorage, 1980.

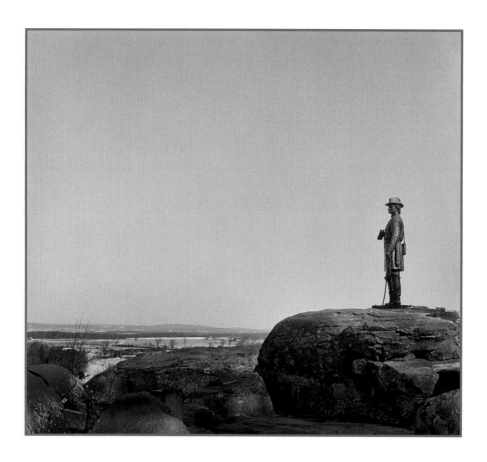

Figure 97. Statue of General Gouverneur Warren, posthumously erected on Little Round Top, Gettysburg, Pa. 2015.

build his pyramid, but if he had a lot of trustees, contractors and newspaper reporters to worry him, he might not have finished by this time."[60]

For Emily, protecting her husband may have been, in part, a response to having witnessed the demise of her brother. General Gouverneur Warren was falsely blamed for a military defeat and relieved of his command after the Civil War battle of Five Forks. He was a broken man and only posthumously, was his name to be cleared. As the historian McCullough recounts:

> It was a heartbreaking thing to see the men who mattered most in her life victims of such dreadful misfortune. It must have seemed as though the two of them, with their pride and decency, their old-fashioned sense of duty, were somehow out of step with the times and paying an awful price for it. Everywhere about her, lesser men, witless, vulgar, corrupt, men of narrow ambition and the cheapest of values were prospering as never before.
>
> This Gilded age, as Mark Twain had named it, seemed to be tailor made for that sort. It was the grand and glorious heyday of the political bribe, the crooked contract, the double standard

Figure 98. Fireworks over the Brooklyn Bridge, 1983.

at every level. . . . Good and brave men who had a legitimate claim to honor, respect, position—at least according to every standard she had been raised by—were somehow in the way now and swept aside.[61]

In July 1883, the bridge was completed with much fanfare. President Chester A. Arthur and a group of dignitaries from the world over gathered in tribute. Emily hosted a reception in their Brooklyn home. Looking pale and wan, remaining in a state of virtual detachment from the public, Washington Roebling endured the ceremonies, his final task as chief engineer.

It was a full decade later that Washington walked the span with Emily, unnoticed and unrecognized by others. What their thoughts were during that experience are unknown.

Freed from the Brooklyn Bridge, the Roeblings eventually moved back to Trenton where they built a large mansion and remained active while pursuing their own interests.

Emily embarked on her own path in the years that followed the opening of the bridge. She took frequent trips while her husband remained at home in Trenton. On several occasions, she traveled to Europe, where she was officially presented to the Queen of England, and then traveled on the Orient Express east to Russia to witness the coronation of the Czar Nicolas II.

Emily demonstrated her independence by advancing the cause of women. She joined and organized clubs and associations and campaigned for the women's right to vote. She became vice president of the Daughters of the American Revolution and offered her time to the Society for the Aid of Friendless Women and Children, the Sorosis Committee, and the Hugenot Society. In 1899, Emily provided aid to soldiers using her own finances. She helped to establish a medical facility at Montauk, Long Island. In 1899, she was the first woman to earn a certificate in New York University's Women's Law Class. Her final essay, "A Wife's Disabilities," called for the elimination of laws discriminating against women in divorce proceedings. "No one denies that marriage is a contract, and that a woman gives all she has to give to the man she takes as her husband. Does she not contribute largely to his success or failure in life? Must she not bear poverty and reverse of fortune with her husband when they come, and shall she not lawfully share in all the profits of his success and prosperity?"[62]

In her remaining years, Emily published *The Journal of the Reverend Silas Constant*, a book of family genealogies. She edited its contents with great care, further attesting to her dedication to preserving family legacies.

Figure 99. Emily Roebling in cap and gown celebrating
her New York University School of Law graduation, 1903.
Courtesy of Rutgers University Libraries, Special Collections Library.

Figure 100 a, b. Emily Roebling's Scrapbooks
on tables at the Roebling Collection Institute
Archives and Special Collections Library,
Rensselaer Polytechnic Institute, 2016.
PORTFOLIO / outtake IMAGES

During this period, Emily's health declined as the
strain of the years in Brooklyn had finally caught up to her.
She suffered from failing eyesight but continued on with her
duties. Similar to her husband, the doctors attributed her
deteriorating condition to excessive overwork. Emily tragically
developed stomach cancer and died in 1903 at age fifty-nine,
leaving behind a grieving husband.

Washington and Emily were avid letter writers and left
behind a formidable collection of correspondence. However,
their personal letters to friends, relatives, and to their own
son, shed little light on the nature of their relationship. It has
been suggested that Washington may have burned some of
his wife's letters to guard their privacy, but that has never
been proven.

In the decade following the opening of the Brooklyn Bridge,
Washington would face another challenge. This one would be

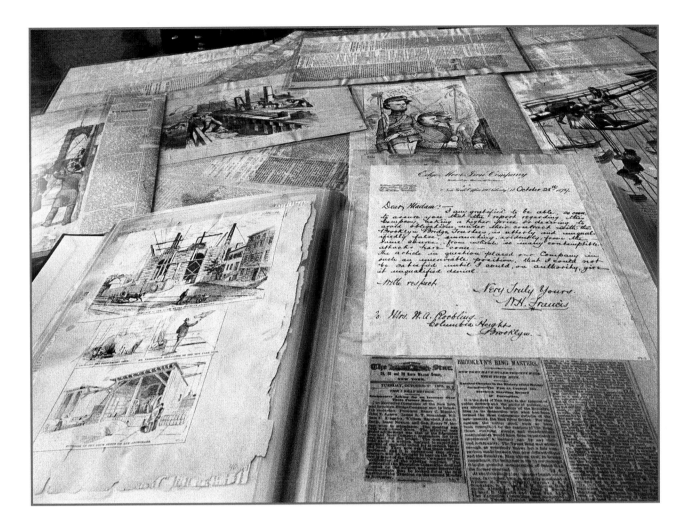

personal. He would begin to write a memoir. Washington Roe-
bling's recollections would look back on his life tinged with
melancholy. He longed at this late date, to separate his identi-
ty from that of his father, having remarked earlier, "Long ago
I ceased my endeavor to clear up the respective identities of
myself and my father. Many people think I died in 1869."[63]
Throughout the decade, he would stop and start the process
of writing, eventually retreating from his self-imposed task.

However, 1908 proved to be a pivotal year for him.
After mourning the loss of Emily for five years, he remarried.
Family members were hoping that his second marriage could
distract him from his "gloomy" outlook, a disposition that had
lasted for decades. In the same year, his father's statue was
unveiled in Cadwalader Park in Trenton. During its creation,
Washington posed as a "stand-in" for his deceased father
reinforcing his frustration in the merging of their identities.
This circumstance could have been a possible catalyst to
continue writing his memoir.[64]

Washington was now an old man looking back on his life. As in Swedish filmmaker Ingmar Bergman's *Wild Strawberries*, which shared a similar theme, Washington portrayed in vivid language the circumstances of his life and the people who either gave love or withheld it. The memoir became an internal conversation reflecting rage against his father, John A. Roebling.

During these years, Washington continued with his life, which was characterized by quiet, solitude, while enjoying the company of his second wife Cornelia, who became devoted to his every need. He had been well enough to delve into his passion and fascination for mineralogy and expanded his unique collection. He enjoyed the companionship of a stray dog he named "Billy Sunday" who would accompany him to his office at the mill where he would write and answer correspondence. To find solace, Washington turned to nature and botany.

Washington lived longer than many of his family members including his brothers Charles and Ferdinand, who were actively running the family's wire rope business, John A. Roebling's Sons. Gone from the earth were political and professional adversaries, friends, and acquaintances: he was truly the last man standing. Although Washington had struggled with his health for most of his adult life, he outlived them all.

The completion of the Brooklyn Bridge depended on the unique character of each Roebling—John, Washington, and Emily. It was John Roebling's unrelenting faith in his work that catapulted him into history. The master builder treasured every hour as though he had a premonition of destiny. His culminating work was a race against death. He found time to attend professional meetings and scientific conventions, write voluminously for technical journals, practice the flute and piano, study metaphysics and put forth his conclusions in lengthy manuscripts, invent machinery and equipment and make his own drawings and models for the Patent Office, survey canals and build portage railways, create and develop a new industry, design aqueducts and bridges and himself superintend their construction—how he achieved all this in his limited lifetime bewilders the imagination.[65]

Washington Roebling described his father's endless capacity for work and his resolute belief in his own ideas:

Few people that I ever met possessed such an amount of vital energy coupled at the same time with amazing perseverance which never rested . . . week day or Sunday—from early morn to dewy eve and later—We all know that mere thought without expression is useless. His every thought was put down in a drawing, a plan or in writing.

He conquered everything with that wonderful personal force, a power which only fed on opposition and knew no defeat.[66]

Washington Roebling's great talent was paradoxical. He faulted himself for lacking a rebellious spirit: "My father had knocked it all out of me, just what I needed most in life."[67]

But it was precisely because he obeyed his father and labored since childhood as his father's assistant that Washington was prepared to fulfill the task of chief engineer of the Brooklyn Bridge. One could argue had Washington chosen to act in his own self-defense, perhaps he would not have followed in his father's footsteps to become an engineer. However, Washington Roebling shared his father's extraordinary intelligence and the German ethic of hard work. His true gift was to be found in the decision-making process; to see the job through, no matter what the risk.

Many years later, in 1917, when Roebling was once again called in to run the family company, John A. Roebling's Sons, a reporter asked him, "How do you keep young and on the job at 84?" Roebling replied: "Because it's all in my head. Sixty years I've known it all, and it's all there yet. It's my job to carry the responsibility and you can't desert your job. You can't slink out of life or out of the work life lays on you. I've lived through hard times before and I can do it again."[68]

Years after Washington Roebling's death, Hart Crane took up residence in the house Roebling had occupied on Columbia Heights. Crane placed his writing desk beside the same bay window that Washington had positioned his telescope forty years before. In the very same location, Crane began work on his own epic poem, "The Bridge."

It is to Emily Roebling that we owe so much. Just as her husband achieved greatness in service to his father, she too achieved greatness in service to her husband. Although convention required a husband to protect his wife, Emily protected her husband by fulfilling many responsibilities required of

the Chief Engineer, leaving her home to navigate an endless gauntlet of public relation obstacles—negotiating with assistant engineers, foremen of construction crews, politicians, contractors, lawyers, businessmen, trustees of the bridge, and the press. The success of her heroic work depended on her extraordinary stamina and steadfastness.

Emily assembled an archive of articles and correspondence, which chronicled the triumphs and tragedies of the project. The exercise of cutting and clipping articles from newspapers and magazines and the archiving of much of the business correspondence lasted for more than a decade.

The scrapbooks in themselves are an immense work, which served not only to chronicle the progress in the construction of the Brooklyn Bridge, but also as a gesture of defiance to their detractors.

It was a relentless exercise. She worked on her archive each day, twice daily. Ultimately, Emily secured the rightful place in history for her husband and father-in-law.

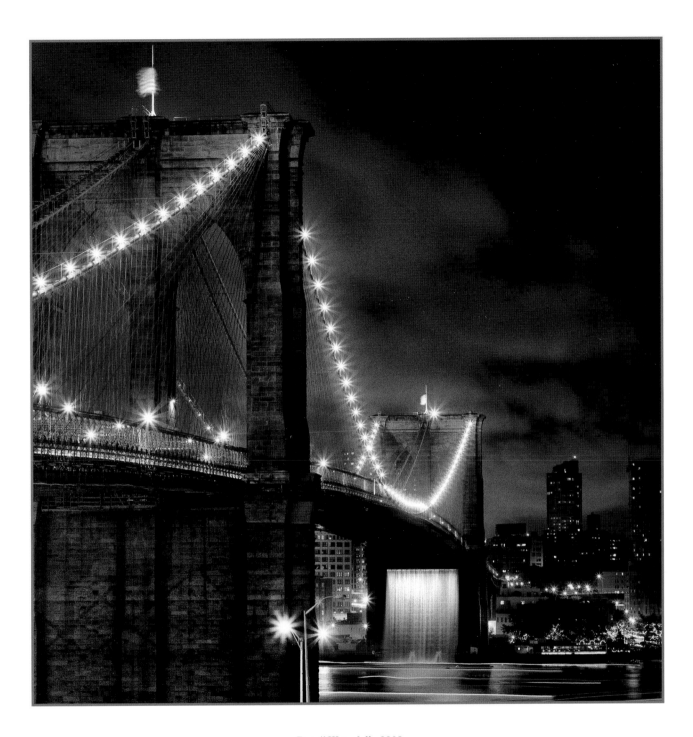

Detail Waterfalls, 2008

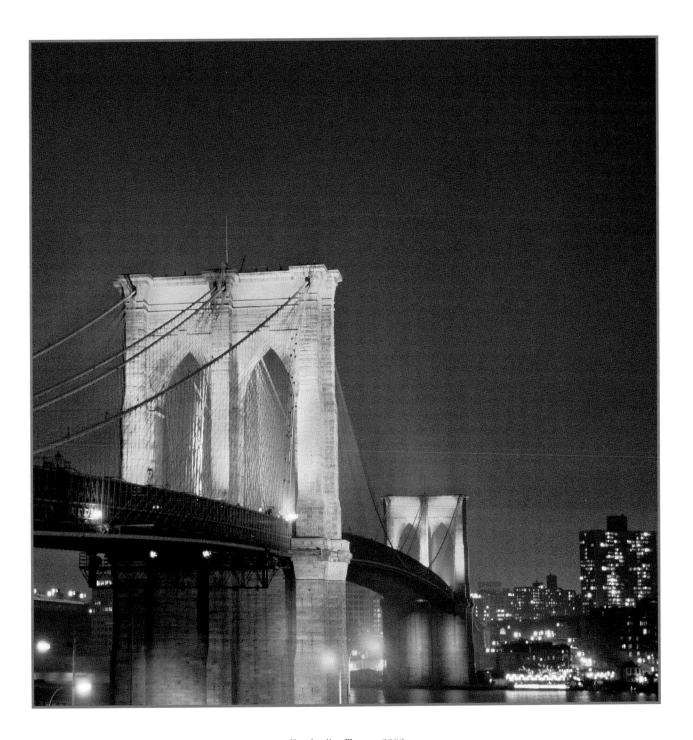

Foreboding Towers, 2002

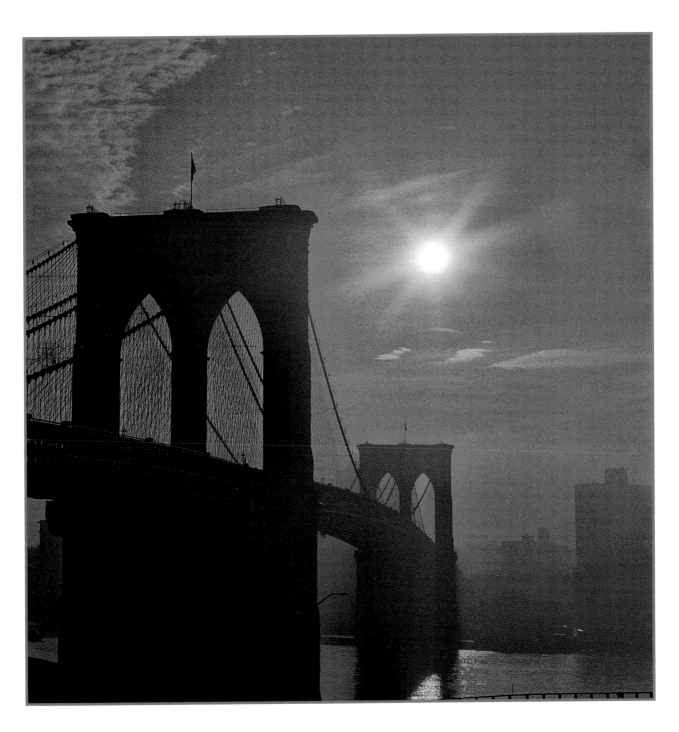

Dark Skies, 1999

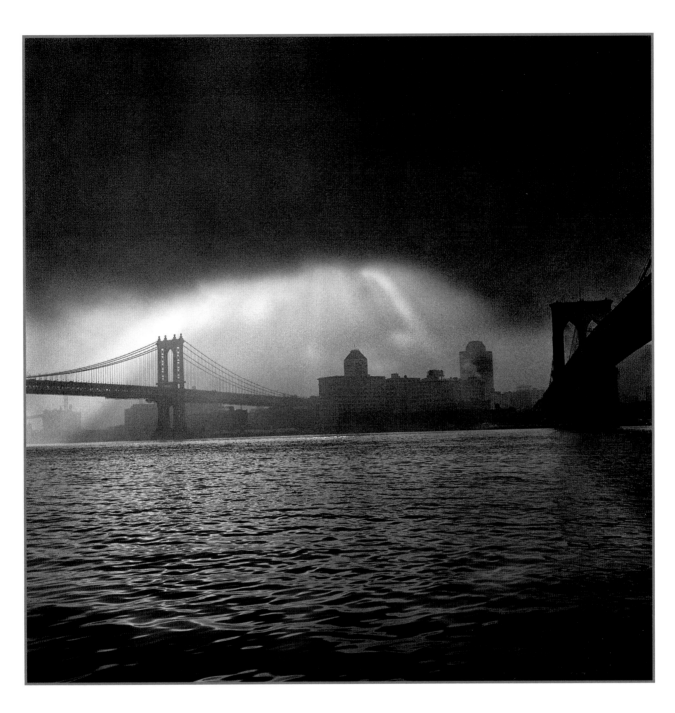

East River in Storm, 1998

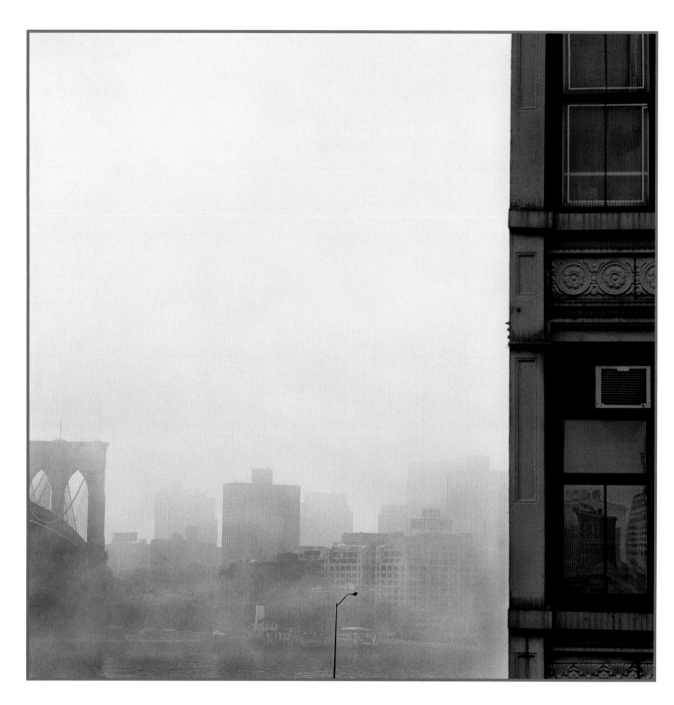

View from Roof, 2009

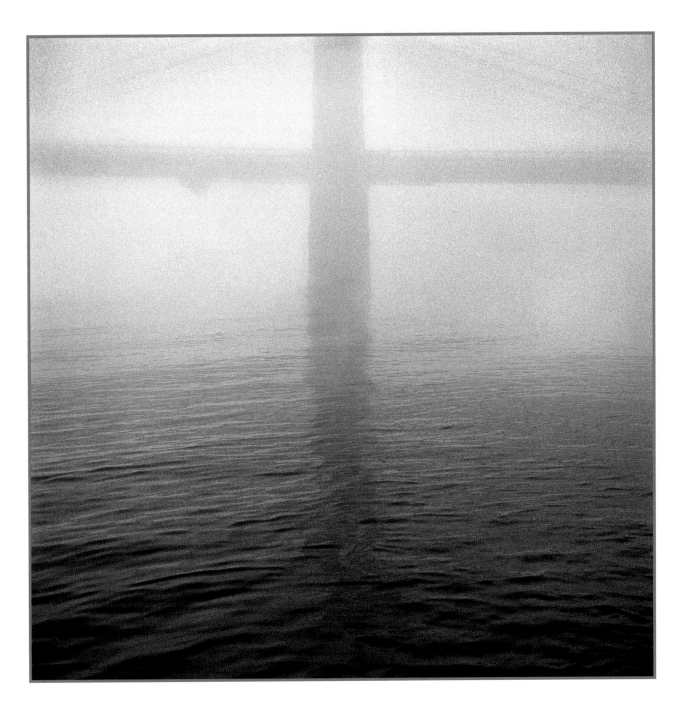

Bridge Lagoon, 2003

Brooklyn Bridge # 1, 1998

"Untitled," 2009

"Untitled," 2009

My quest to explain what I perceive to be the genius of the Roeblings ended in defeat and left me with more questions than I had when I embarked on this journey many years ago. It was sobering to realize that searching for a concrete definition was impossible; identifying *genius* was elusive and mysterious, not unlike a puzzle that is impossible to solve.

The ancient Romans described genius as a guardian spirit, a deity that followed a person on their life's journey. Over the centuries, this description gradually evolved as progress in the natural sciences, philosophy, and psychology changed our perceptions of and feelings about the nature of genius. Attempting to define genius became both a challenge and a balancing act between rational assessment and irrational beliefs, between fact and conjecture.

Experts have grappled with its definition, offering a theory that genius was accompanied by a "dark side" of one's personality. Gifted souls afflicted with bouts of schizophrenia, severe depression, bipolar disorders, nervousness, and high anxiety would also experience great spurts of remarkable creative energy, suggesting a strong link between the two. Although this compelling theory has been seriously considered, it has never been proven. Some professionals even theorized that genetics plays a critical role, posing the question: Is genius hereditary?

John Augustus Roebling indisputably exhibited traits that have the mark(s) of a genius. He was haunted by his internal demons throughout his lifetime. He also left behind a sublime record of his ingenuity and many creative talents. He was a great engineer and artist for sure.

But is character separate from genius? Does indefatigable strength and persistence under adversity reveal a sign of genius? Certainly, Washington Roebling's strength of character was his fortitude.

Do heightened instincts, physical stamina, and the will to succeed—which are characteristic of many successful individuals—describe genius? If so, then Emily Roebling certainly could be considered a genius.

I pondered the long history of those whose work went unnoticed, misunderstood, or rejected during their lifetimes. Likened to passing through a sieve, their extraordinary talents, changing the way we view the world, were to be sorted out through time. The list is daunting and includes some of the greatest thinkers and creative individuals, including Atget, Bach, Caravaggio, Copernicus, Dickinson, Freud, Galileo, Kafka, Mendel, Poe, Thoreau, Van Gogh, and Vermeer.

Although the Brooklyn Bridge is one of the most recognizable man-made monuments in the world, its creators, in my eyes, do not enjoy the fame and recognition they deserve for their ingenuity, sacrifice, and endurance to see this project through from concept to completion.

Living in the shadow of the Brooklyn Bridge has changed me. At the end of my journey, I was unable to return to the place where I started, when I took my first photographs of the bridge. The Roeblings have become my "guardian spirits," as I am now in a better position to recognize my own strengths and frailties. I continue on a path toward the unknown, taking each step within the shadow of their genius.

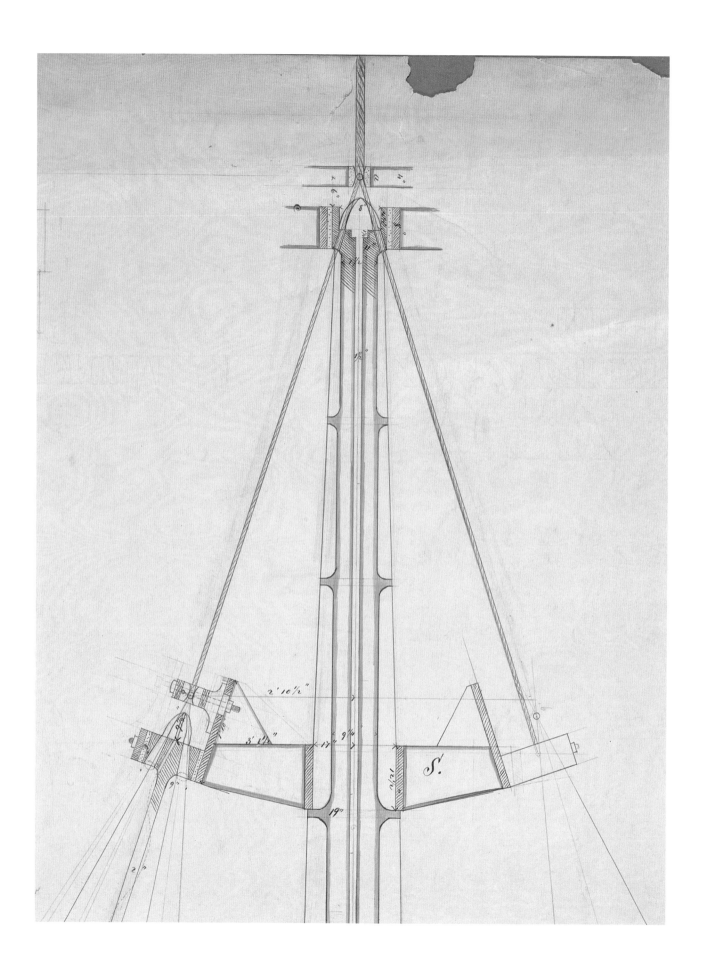

ACKNOWLEDGMENTS

It's a challenge to tell a good story. As a visual artist, one strives to perfect and refine, always looking to create the next image. In this book, I sought to tell a story by combining the historical record with contemporary photography. I'm deeply grateful to all those who helped me meet this daunting challenge.

In 2009, Bonnie Yochelson first brought my collection of Brooklyn Bridge images to public attention with an article in the *New York Times*. A few years later, she helped me produce a Brooklyn Bridge portfolio and catalog of images. Bonnie also shaped and honed the manuscript for this book with critical insight, discerning the universal points to be made. Without her guidance, assembling the project would not have been possible. I am deeply indebted to Fernanda Perrone, archivist, historian, and curator at Rutgers University Libraries for giving me access to the Roebling Family Collection. Leaving me in a secure room with the original notebooks of John Augustus Roebling was a truly thrilling experience. I also am grateful to Fernanda for acquiring my photographs of the Brooklyn Bridge for the Special Collections Library, and for writing the foreword to this book.

John Cyr assisted in printing many of the original photographs. Together we formed a lasting friendship based not only on our reverence for the medium of photography but also for the mutual respect we share for one another. Dot Editions under the expert supervision of Rocky Kenworthy, produced the original scans for the book. In the latter part of the project, Sergio Purtell and his assistant Andrew Jarman at Black and White on White provided skillful interpretations of the digital scans.

Filmmaker Simone Furbringer accompanied me on my trip to Mühlhausen. Her skills in translating and seeking out the individuals to interview was an invaluable component of the book. Her talent, humor, diplomatic skills, and overall enthusiasm for life made our bond stronger. Her partner, Nicolas Humbert, a visionary filmmaker, endlessly inspires me. I treasure lifelong friendships with Ute Ritschel, her husband, Jürgen Heinz, and Johannes Birringer. In Munich, the exceptional Blow Up Lab processed my negatives with utmost care. Claus Vogel and Alex Nusslein offered wonderful insights and friendship. In Mühlhausen, the archivist Roswitha Henning, Pfarrer Schwarze, and Christian Wachsmann took me on a remarkable journey into Germany's past. Anne Gibbs of White Mule Framing became a wonderful friend and I thank her for her beautiful frames and expediting my work to exhibitions on time. Thanks to Spike Jones Jr.

Evelyne Daitz of the Witkin Gallery continues to provide me with wise counsel and assurance. Phillip Lopate continues to be a force in my life. My respect and affection for this gifted writer goes beyond the normal boundaries. He is a true kindred spirit and I have been honored to have him play a critical role offering guidance and advice.

Historian John Heiser was busy at work on the coldest day of winter at the Gettysburg National Military Park. With great enthusiasm, he was able to answer all of my questions about the great Civil War battles. Amy Rupert, Jennifer Monger, and Tammy Gobert assisted me at Rensselaer Polytechnic Institute and allowed me to photograph precious scrapbooks of Emily Roebling and master drawings of John Roebling, Washington Roebling, and William Hildenbrand. Ken Cobb, of the Municipal Archives in New York supplied a beautiful drawing executed by Washington Roebling in 1869.

The International Center of Photography offered me the opportunity to share some of the ideas expressed in this publication with my students. Suzanne Nicholas has been a wonderful advocate. Artist Claire Gilliam helped to bring the book with its many moving parts into a solid work. Her contribution was invaluable. I have truly appreciated working with Fred Nachbaur, Will Cerbone, Kate O'Brien-Nicholson, Eric Newman, Jennifer Richards, and Ann-Christine Racette at Fordham University Press. Special thanks to Michael Koch, who edited the manuscript (a difficult task indeed).

As always, thanks to family members, and special loved ones including Victor and Sarah Kovner, Sue and Bern Phillips, Edith Gould with whom I engaged in detailed conversations about "genius," and Gregory Stone Curry, who accompanied me on many of my location shoots and research opportunities.

In the tower of Divi Blasius Church.
Photo credit: Simone Furbringer

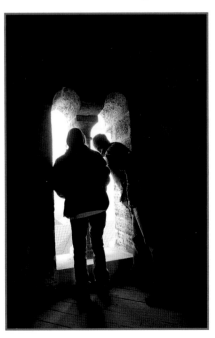

The Mysterious Piano, 2016

ENDNOTES

1. David McCullough, *The Great Bridge: The Epic Story of the Building of the Brooklyn Bridge* (New York: Simon and Schuster, 1972), 334, passim.

2. D. B. Steinman, *The Builders of the Bridge: The Story of John Roebling and His Son* (New York: Harcourt Brace and Company, 1945; repr. Arno, 1972), 25.

3. Ibid., 4, 5.

4. Donald Sayenga, ed., *Washington Roebling's Father: A Memoir of John A. Roebling* (Reston, VA: American Society of Civil Engineers, 2009), 208.

5. Steven Stoll, *The Great Delusion, a Mad Inventor, Death in the Tropics, and the Utopian Origins of Economic Growth* (New York: Hill and Wang, 2008), 28.

6. Ibid., 27.

7. Ibid., 27.

8. Steinman, *Builders of the Bridge*, 20.

9. Brooke Hindle, "The American Revolution through its Survivals," in *Science and Society in Early America, Essays in Honor of Whitfield J. Bell, Jr.*, ed. Randolph Shipley Klein (Philadelphia: American Philosophical Society, 1986), 296, 298.

10. Hamilton Schuyler, *The Roeblings—A Century of Engineers, Bridge Builders and Industrialists: The Story of Three Generations of an Illustrious Family* (Princeton, NJ: Princeton University Press, 1931), 32.

11. Ibid., 33.

12. Andreas Kahlow, "Johann August Röbling (1806–1869): Early Projects in Context," in *John A. Roebling: A Bicentennial Celebration of His Birth 1806–2006*, ed. Theodore Green (Reston, VA: American Society of Civil Engineers, 2006).

13. Sayenga, *Washington Roebling's Father*, 43.

14. Charles Dickens, *American Notes for General Circulation* (London: Chapman Hall, 1842; repr. Applewood Books, 2007), 106.

15. Cited in Allan Trachtenberg, *Brooklyn Bridge: Fact and Symbol* (Oxford: Oxford University Press, 1965), 54.

16. Donald Sayenga, *Ellet and Roebling* (York, PA: American Canal and Transportation Center, 1983), 22.

17. Schuyler, *Roeblings*, 57.

18. Ibid., 53–54.

19. Ibid., 68.

20. Cited in Trachtenberg, *Brooklyn Bridge*, 64.

21. Sayenga, *Washington Roebling's Father*, 39.

22. Ibid., 92.

23. Ibid., 144.

24. Ibid., 108.

25. Steinman, *Builders of the Bridge*, 142.

26. Sayenga, *Washington Roebling's Father*, 129–130.

27. Ibid., 153.

28. "John A. Roebling," *Beecher's Illustrated Magazine*, vol. 3 (January 1871), 131.

29. Sayenga, *Washington Roebling's Father*, 153.

30. Schuyler, *Roeblings*, 95.

31. Sayenga, *Washington Roebling's Father*, 155.

32. Ibid., 161.

33. Ibid., 163–164.

34. Ibid., 39.

35. *Sayenga, Washington Roebling's Father, pg 192*

36. Washington A. Roebling, *Civil War Memoirs*, 233, Roebling Family Collection, Special Collections and University Archives, Rutgers University Libraries, (microfilm).

37. Ibid., 307.

38. Ibid., 312–314.

39. Ibid., 315–316.

40. Ibid., 317–318.

41. Ibid., 318–319.

42. Ibid., 321.

43. Ibid., 321.

44. Letter dated February 28, 1864, from Washington to his sister, Elvira, cited in Clifford W. Zink, *The Roebling Legacy* (Princeton, NJ: Princeton Landmark Publications, 2011), 62.

45. Letter to Emily, June 22, 1864, Washington Roebling letters; Rutgers University archive.

46. Zink, *Roebling Legacy*, 63.

47. McCullough, *The Great Bridge*, 164.

48. Zink, *Roebling Legacy*, 64.

49. Sayenga, *Washington Roebling's Father*, 201.

50. McCullough, *Great Bridge*, 69–70.

51. Sayenga, *Washington Roebling's Father*, 206.

52. *Report of John A. Roebling, C.E., to the President and Directors of the New York Bridge Company, on the proposed East River Bridge* (Brooklyn, NY: Daily Eagle Print, 1867), 3–4.

53. Marilyn E. Weigold, *Silent Builder: Emily Warren Roebling and the Brooklyn Bridge* (Port Washington, NY: Associated Faculty Press, 1984).

54. See Deborah Nevins, "1869–1883–1983," in *The Great East River Bridge, 1883–1983*, ed Brooklyn Museum (New York: The Museum; Abrams, 1983), 23.

55. W. A. Roebling, *Pneumatic Tower Foundations of the East River Suspension Bridge* (New York: George W. Averell, 1872), 11.

56. Sayenga, *Washington Roebling's Father*, 232.

57. See Nevins, "1869–1883–1983," 23–28.

58. McCullough, *Great Bridge*, 320.

59. Ibid., 343.

60. Ibid., 522.

61. Ibid., 462.

62. Emily Warren Roebling, "A Wife's Disabilities," *Albany Law Journal* (April 15, 1899).

63. McCullough, *Great Bridge*, 560.

64. Ibid., 556.

65. Steinman, *Builders of the Bridge*, 123.

66. Sayenga, *Washington Roebling's Father*, 210.

67. Ibid., 157.

68. McCullough, *Great Bridge*, 559.

REFERENCES

Archives

Brooklyn Historical Society. Private love letters of Washington Roebling and Emily Warren.

Mühlhausen Stadt Archives. Records concerning early years of Johann Röbling and ancestral documents.

New York City Municipal Archives. Brooklyn Bridge interior drawings on microfilm.

The Roebling Collection. Institute Archives and Special Collections, Folsom Library, Rensselaer Polytechnic Institute. Emily Roebling scrapbooks. Notes and records of John A. Roebling. Notes and Records of Washington A. Roebling.

Rutgers University Libraries. Special Collections. The Roebling Family Collection: MC654 Private letters of Washington Roebling (microfilm); *Civil War Memoirs* by Washington A. Roebling; Private letters of Emily Warren Roebling; John Roebling's drawings and notebooks; Washington Roebling's letters and notebooks.

Brooklyn Daily Eagle. Articles from 1867–1883.

New York Times. Articles about Brooklyn Bridge construction from 1878–1883.

Scientific American Illustrations. about Brooklyn Bridge construction from 1872–1883

Trenton Times, "Washington Roeblings Drawings" April 20, 1975

Other Sources

Barnes, A. C. *The New York and Brooklyn Bridge*. Pamphlet. Brooklyn, 1883.

Barber, Alfred Newton. *John A. Roebling: An Account of the Ceremonies at the Unveiling of a Monument to his Memory*. Roebling Press, 1908.

Charles River Editors, *The Most Famous Landmarks of New York City*. N.p., 2005.

Dickens, Charles. *American Notes for General Circulation*. London: Chapman Hall, 1842. Repr. Applewood Books, 2007.

Hindle, Brooke. "The American Revolution through its Survivals." In *Science and Society in Early America, Essays in Honor of Whitfield J. Bell, Jr.*, edited by Randolph Shipley Klein. Philadelphia: American Philosophical Society, 1986.

Jordan, David M. *Happiness Is Not My Companion: The Life of General G. K. Warren*. Indianapolis: Indiana University Press, 2001.

Hatch-Draper, Kelley Marie. "Wired for Business: The Roebling Story" 2011. Electronic Theses and Dissertations. Paper 1282, http://dc.etsu.edu/etd/1282.

Kahlow, Andreas. "Johann August Röbling (1806–1869): Early Projects in Context." In *John A. Roebling: A Bicentennial Celebration of His Birth 1806–2006*, edited by Theodore Green. Reston, VA: American Society of Civil Engineers, 2006.

Lopate, Phillip. *Waterfront: A Joourney Around Manhattan*. New York: Crown Publishers, 2004.

McCullough, David. *The Great Bridge: The Epic Story of the Building of the Brooklyn Bridge*. New York: Simon and Schuster, 1972.

Nevins, Deborah. "1869–1883–1983." In *The Great East River Bridge, 1883–1983*, edited by Brooklyn Museum. New York: The Museum; Abrams, 1983.

Osterberg, Matthew M. *The Delaware and Hudson Canal and the Gravity Railroad*. Charleston, SC: Arcadia Publishing, 2002.

Report of John A. Roebling, C.E., to the President and Directors of the New York Bridge Company, on the

proposed East River Bridge. Brooklyn, NY: Daily Eagle Print, 1867.

Roebling, Emily Warren. "The Journal of the Reverend Silas Constant." Philadelphia, PA: JB Lippincott Company, 1903.

Roebling, John A. *Final Report to the Presidents and Directors of the Niagara Falls Suspension and Niagara Falls International Bridge Companies. May 1, 1855 Rochester*. New York: Steam Press of Lee Mann and Co, 1855.

Roebling, John Augustus. *Diary of My Journey from Muehlhausen in Thuringia via Bremen to the United States of North America*. Mühlhausen Stadt archives, Germany.

Roebling, Washington A. *Early History of Saxonburg*. Saxonburg, PA: Butler County Historical Society, 1924.

Roebling, Washington A. *Pneumatic Tower Foundations of the East River Suspension Bridge*. New York: George W. Averell, 1872.

Sayenga, Donald. *Ellet and Roebling*. York, PA: American Canal and Transportation Center, 1983.

Sayenga, Donald, ed. *Washington Roebling's Father: A Memoir of John A. Roebling*. Reston, VA: American Society of Civil Engineers, 2009.

Schuyler, Hamilton. *The Roeblings—A Century of Engineers, Bridge Builders and Industrialists: The Story of Three Generations of an Illustrious Family*. Princeton, NJ: Princeton University Press, 1931.

Shapiro, Mary J. *A Picture History of the Brooklyn Bridge*. New York: Dover Books, 1983.

Singer, Peter. *Hegel: A Very Short Introduction*. New York: Oxford University Press, 1983.

Steinman, D. B. *The Builders of the Bridge: The Story of John Roebling and His Son*. New York: Harcourt Brace and Company, 1945. Repr. Arno, 1972.

Stoll, Steven. *The Great Delusion, a Mad Inventor, Death in the Tropics, and the Utopian Origins of Economic Growth*. New York: Hill and Wang, 2008.

Stuart, Charles B. *Lives and Works of Civil and Military Engineers of America*. New York: D. Van Nostrand, 1871.

Tolzman, Don Heinrich. *John A Roebling and His Suspension Bridge Over the Ohio River*. Little Miami Publishing Company, 2007.

Trachtenberg, Alan. *Brooklyn Bridge: Fact and Symbol*. Oxford: Oxford University Press, 1965.

Vogel, Robert. *M. Roebling's Delaware & Hudson Canal Aqueducts* Philadelphia, PA: Eastern National Park and Monument Association, 1986.

Weigold, Marilyn E. *Silent Builder: Emily Warren Roebling and the Brooklyn Bridge*. Port Washington, NY: Associated Faculty Press, 1984.

Zink, Clifford W. *The Roebling Legacy*. Princeton, NJ: Princeton Landmark Publications, 2011.

Select titles from Empire State Editions

Andrew J. Sparberg, *From a Nickel to a Token: The Journey from Board of Transportation to MTA*

New York's Golden Age of Bridges. Paintings by Antonio Masi, Essays by Joan Marans Dim, Foreword by Harold Holzer

Daniel Campo, *The Accidental Playground: Brooklyn Waterfront Narratives of the Undesigned and Unplanned*

John Waldman, *Heartbeats in the Muck: The History, Sea Life, and Environment of New York Harbor, Revised Edition*

John Waldman (ed.), *Still the Same Hawk: Reflections on Nature and New York*

Gerard R. Wolfe, *The Synagogues of New York's Lower East Side: A Retrospective and Contemporary View, Second Edition*. Photographs by Jo Renée Fine and Norman Borden, Foreword by Joseph Berger

Joseph B. Raskin, *The Routes Not Taken: A Trip Through New York City's Unbuilt Subway System*

North Brother Island: The Last Unknown Place in New York City. Photographs by Christopher Payne, A History by Randall Mason, Essay by Robert Sullivan

Kirsten Jensen and Bartholomew F. Bland (eds.), *Industrial Sublime: Modernism and the Transformation of New York's Rivers, 1900–1940*. Introduction by Katherine Manthorne

Richard Kostelanetz, *Artists' SoHo: 49 Episodes of Intimate History*

Stephen Miller, *Walking New York: Reflections of American Writers from Walt Whitman to Teju Cole*

Tom Glynn, *Reading Publics: New York City's Public Libraries, 1754–1911*

Craig Saper, *The Amazing Adventures of Bob Brown: A Real-Life Zelig Who Wrote His Way Through the 20th Century*

R. Scott Hanson, *City of Gods: Religious Freedom, Immigration, and Pluralism in Flushing, Queens*. Foreword by Martin E. Marty

Dorothy Day and the Catholic Worker: The Miracle of Our Continuance. Edited, with an Introduction and Additional Text by Kate Hennessy, Photographs by Vivian Cherry, Text by Dorothy Day

Robert Weldon Whalen, *Murder, Inc., and the Moral Life: Gangsters and Gangbusters in La Guardia's New York*

Joanne Witty and Henrik Krogius, *Brooklyn Bridge Park: A Dying Waterfront Transformed*

Sharon Egretta Sutton, *When Ivory Towers Were Black: A Story about Race in America's Cities and Universities*

Pamela Hanlon, *A Wordly Affair: New York, the United Nations, and the Story Behind Their Unlikely Bond*

Britt Haas, *Fighting Authoritarianism: American Youth Activism in the 1930s*

David J. Goodwin, *Left Bank of the Hudson: Jersey City and the Artists of 111 1st Street*. Foreword by DW Gibson

Nandini Bagchee, *Counter Institution: Activist Estates of the Lower East Side*

Carol Lamberg, *Neighborhood Success Stories: Creating and Sustaining Affordable Housing in New York*

Ron Howell, *Boss of Black Brooklyn: The Life and Times of Bertram L. Baker*

Susan Celia Greenfield, *Sacred Shelter: Thirteen Journeys of Homelessness and Healing*

Andrew Feffer, *Bad Faith: Teachers, Liberalism, and the Origins of McCarthyism*

Susan Opotow and Zachary Baron Shemtob (eds.), *New York after 9/11*

Elizabeth Macaulay-Lewis and Matthew McGowan (eds.), *Classical New York: Discovering Greece and Rome in Gotham*

For a complete list, visit www.empirestateeditions.com.